PHILIP GUSTON'S POOR RICHARD

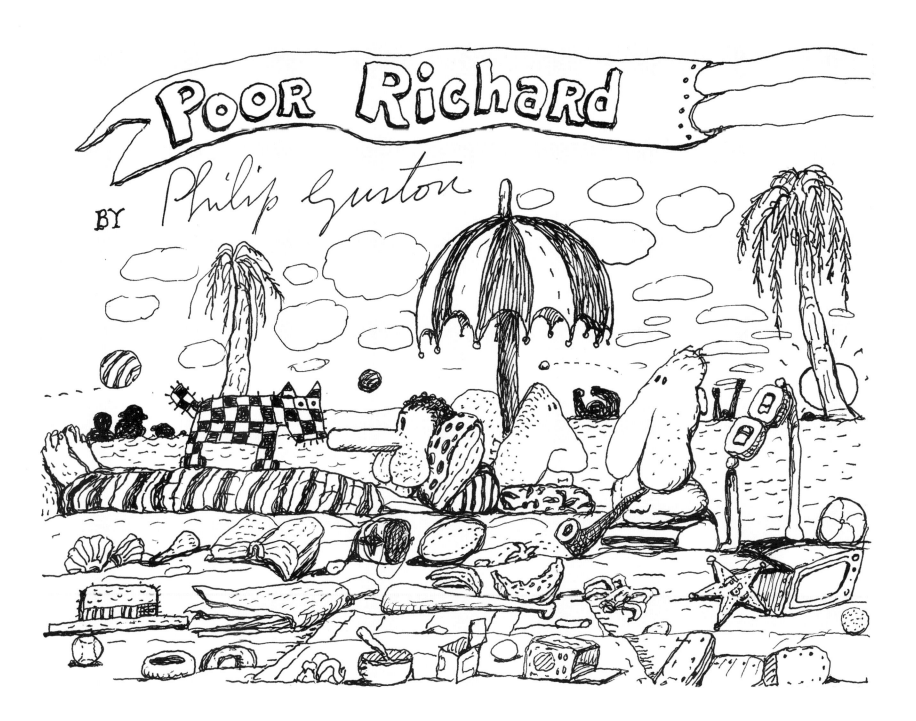

PHILIP GUSTON'S POOR RICHARD

DEBRA BRICKER BALKEN

Part One: Prelude

What has happened to me? he thought. It was no dream.—Franz Kafka, *The Metamorphosis*

You know, nobody will believe it, but I'm really an egghead.—Richard Nixon, *Los Angeles Times*, March 2, 1961

MUTT *AND* JEFF, *AND THE TARTUFFISMS OF A PRESIDING PRESIDENT*

Sometime during the summer of 1971, Philip Guston (1913–1980) began a visual narrative of Richard Nixon's life, a series of almost eighty drawings that caught one of America's most maligned politicians in a depraved, monstrous state. Titled *Poor Richard*, these caricatures play on the brooding, self-pitying character that Nixon exuded throughout his life. While much has been made in the ongoing interpretations of the radical content of Guston's late work—of his brash betrayal of abstract painting and the New York School and his introduction of quirky, incongruous, cartoon-type figures and shapes around 1968—nothing quite approximates the mocking and satiric nature of these renderings of an American president. Their transgressive nature explains, perhaps, the deep ambivalence that Guston felt in pursuing his initial plan to publish the images as a book, and the reason they have remained almost wholly unknown to date.[1]

Like Guston's *Poem-Pictures* or the collaborations he effected with various writers during the last decade of his life, *Poor Richard* grew out of a friendship with a neighbor, Philip Roth, the novelist, who began living near Guston in Woodstock, New York, in 1969. Roth, after the wild success of *Portnoy's Complaint* and, as he put it, "overnight notoriety as a sexual freak,"[2] felt the need to avoid Manhattan, while Guston, who had spent summers upstate intermittently since the late 1930s, moved permanently to his Catskill retreat in 1967. The overwhelmingly hostile reaction to the first exhibition of his late work at the Marlborough Gallery in New York in 1970 had left him feeling undone, as he said, "like I had left the Church, and had been excommunicated"[3] from the mantle of Abstract Expressionism. One particular setback took the form of

a stinging attack by Hilton Kramer for the *New York Times* with an accompanying headline which read "A Mandarin Pretending to Be a Stumblebum." With the exception of a few loyal friends such as Harold Rosenberg, Willem de Kooning and James Brooks, Guston felt cut off, disconnected, from an art world in which he had been previously sought-after and ascendant. The company of writers became his primary social and intellectual outlet.[4] The company of Philip Roth, especially, developed into a pivotal relationship, one that was sustained until Guston's death.

Whatever the difference in age—Guston was almost twenty years older—Roth remembers that an almost instantaneous bond was ignited between the two by "a similar intellectual outlook and a love of many of the same books, as well as delight in what we happened to share in what Guston called 'crapola,' starting with billboards, garages, diners, burger joints, junk shops, auto body shops—all the roadside stuff that we occasionally set out to Kingston to enjoy."[5] In the "crapola," or this degraded and overlooked area of popular culture, both figures located aesthetic possibilities, imagery, they thought, which could liberate their work from the stranglehold of the prevailing canons in literature and art. Guston and Roth both knew that, like the commonplace objects depicted throughout the writing of Franz Kafka and Samuel Beckett—shared literary interests—these diminished pockets of American culture could be mined as potent means to move their work beyond any self-perceived impasse. Guston's once elegiac abstractions, remote yet inherently graceful, yielded around 1967/68 to their visual opposite: to images of the Ku Klux Klan, hanging light bulbs, books, clocks, shoes, and paintbrushes among other disparate figures and things that had come to populate and momentarily destabilize his interior landscape. Whereas Roth, the younger writer, had always juxtaposed mundane and highbrow subjects in his literary take on American life.

In their sometimes weekly gatherings for dinner at each other's houses in Woodstock, these themes would generate endless discussions characterized by intense animation and ebullience. Musa, Guston's wife, came to refer to the pair as "Mutt and Jeff,"[6] an endearment which invoked Bud Fisher's celebrated comic strip and the humorous shape of their banter. Their ongoing preoccupation with "crapola" and with the irony that could be distilled through the representation of the most ordinary object matched the sense of absurdity in Fisher's comics. While these fascinations remained constant, framing, particularly, in the case of Guston the imagery of his late work, the two men also shared a deep contempt for Richard Nixon, the newly elected president. And in Nixon, just as in American popular culture, they located another subject that generated artistic response.

Roth remembers that he and Guston spoke about Nixon "not in any analytic way," but in terms of an "exuberance"[7] for a reviled figure who Roth observed seemed like a comic invention of Molière.[8] They were both transfixed, as he has described, by "the Uriah Heepisms and Tartuffisms of our presiding President,"[9] someone who unwittingly opened himself up to mimicry and caricature. If "crapola" had provided droll dinner conversation, imagine the clowning and mischief that accompanied their weekly renditions of Nixon. In the hypocrisy which attended Nixon's political maneuvering, and in his deep-seated self-pitying nature, Roth and Guston found much to ridicule and ape. Unlike any other president in the twentieth century, Nixon offered countless possibilities for impersonation, a figure who yielded easily to satiric treatment and, as they both found, to art.

Roth's handling of Nixon, and of his administration, took the form of *Our Gang*, a political satire which he began to write in Woodstock in April 1971. The book was specifically prompted by the conviction in late March of Lieutenant William Calley for the 1968 My Lai massacre of a village of unarmed women, children, and elderly men in southern Vietnam. Calley's sentence of life imprisonment ironically induced Nixon's sympathy and involvement, with the result that his conviction was commuted to house arrest and he was released from a federal penitentiary within six months. This intercession, combined with another topical news event—Nixon's declaration of his pro-life position on April 3, 1971—revealed, at least to Roth, an outrageously conflicted morality, one which opened itself to scorn and to attack. In the first chapter of *Our Gang*, these two events are conjoined and enlarged for all their contradiction. Nixon, under the guise of Trick E. Dixon, misrepresents Lieutenant Calley's barbarity as a "form of population control,"[10] a feeble legit-

imization of mass murder, but one which Tricky believes is possible "to square . . . with [his] personal belief in the sanctity of human life."[11] *Our Gang* is divided into six loosely connected chapters that play, as Roth has noted, on "Nixon's style of discourse and thought."[12] The president's deft and boldface reversals of his public statements and political stances are explored for all their convolution through Roth's imitation of his addresses to the nation, press conferences, interviews, with the outcome that Nixon emerges as a supremely deceitful yet pathetic figure, who in one passage even stoops to employ the Boy Scouts as a scapegoat to skew his position on abortion:

> . . . I must admit, never in my long career of dealing with falsehood have I come upon a lie so treacherous and Machiavellian as this one my enemies [the Boy Scouts] are trying to pass off about me . . . *What did I say? Let's look at the record.* I said *nothing! Absolutely nothing!* I came out for "the rights of the unborn." I mean if ever there was a line of hokum, that was it. Sheer humbug! And as if it wasn't clear enough what I was up to, I even tacked on, "as recognized in principles expounded by the United Nations." *By the United Nations.* Now what more could I possibly have said to make the whole thing any more inane? . . . And yet this, *this* is my reward, for my faith in America. The Boy Scouts of America screaming to the TV cameras that Trick E. Dixon favors sexual intercourse. Favors fornication—*between people!*[13]

The canniness with which Nixon was known to maneuver even the most difficult imbroglios—the Calley conviction, for example, was skillfully mitigated and diffused—and his frequent use of pity as a strategic device, are exaggerated in *Our Gang* to ludicrous ends, to morph Nixon and his vanity into, as Roth has said, a "burlesque skit."[14] Throughout the parody, members from Nixon's Cabinet assume comic personas—Henry Kissinger is reinvented as "Secretary Fickle" and Vice President Agnew as "What's-his-name"—while well-known politicos are re-presented as, for example, Governor George Wallow and Senator Hubert Hollow, and past presidents such as John F. Charisma and Lyin' B. Johnson are also woven into the narrative, or masquerade. Only a few characters, such as Alger Hiss, Martin Luther King and Abe Fortis, some of whom were victimized by Nixon's ideological differences, are spared recasting.

Roth recalls that when the first chapter of *Our Gang* appeared in the *New York Review of Books* he became so exhilarated by his sketch of Nixon that he decided to "keep going,"[15] to add to his mockery of the head of state, whom he eventually has assassinated in a penultimate chapter of fantasy and farce. While Roth had, as he has stated, "spent nearly as much time writing satire as . . . fiction"[16] as an undergraduate at Bucknell University—with the result that all his novels are laced with a satirical edge—Nixon threw him back into reconsideration of political satire as a literary genre. Caricature afforded, he realized, "the imaginative flowering of the primitive urge to knock somebody's block off."[17]

Roth showed his piece in the *New York Review of Books* to Guston and mentioned his desire to continue to elaborate on the president's foibles, to develop a cohesive spoof that would draw more fully on the duplicities and pitfalls of Nixon's political actions and speeches.[18] The combination of Nixon's insatiable ambition and apparent lack of principle seemed like fiction to Roth, a perversion of the ideals embodied by the White House. As he noted after *Our Gang* was completed in mid-July of 1971, "Look at him today, positively gaga over his trip to Red China, as he used to call it when he was debating Kennedy. Now he says the 'People's Republic of China' as easily as any Weatherman. Doesn't he stand for *anything?* It turns out he isn't even anti-Communist. He never even believed in *that.*"[19] Guston responded equally to Roth's "exuberance" about taking on Nixon and decided, as the writer remembers, to "chime in."[20]

His own project, *Poor Richard,* a series of caricatures which trace the history of Nixon's life, expounds, like *Our Gang,* on the President's wily deceptions, but with salient differences. *Poor Richard* is not a text. Moreover, it contains no captions and relies exclusively upon Guston's ingenious drawings to convey the chicanery of Nixon and his Cabinet. From the occasional dates that appear alongside Guston's signature on these images, they appear to have been produced during the month of August, in one apparently manic or prolific outburst,[21] after the manuscript for *Our Gang* was sent off to Roth's publishers.[22] Roth read *Poor Richard* as "a parallel activity,"[23] a visual counterpart to his own put-down of Nixon. While both projects are deeply

mocking, building on Roth's and Guston's weekly antics, they converge only as satire, the narrative structure and content being unrelated.

Poor Richard is actually a witty rejoinder to Roth's parody, departing as it does from the writer's preoccupation with the locutions of the president's shifting orations and pronouncements. In its historic sweep of Nixon's life, *Poor Richard* focuses primarily on his ascent to the White House, and specifically on one topical news event: his plan to visit China. The cover sheet, or title page—Guston carefully assembled these images in sequence so that a publisher could follow his prescribed order[24]—pictures the primary cast of characters who will be developed and disparaged throughout. Beneath a floating banner which announces the title of this parody lies Nixon, or Poor Richard, along with his dog Checkers, Agnew, John Mitchell, and Kissinger, on a Key Biscayne beach, amongst a rubble of balls, books, shells, half-eaten fruit, FBI insignia, and a television set. As line drawings on cream-colored stock, these images rely upon a system of symbols to distill the characterological traits of each figure. Nixon is depicted with an elongated nose, which along with his extended jowls assumes the shape of male genitalia; Agnew, ever the dolt, appears as a cone-head in a patterned shirt, his neck studded with nails; Mitchell is identified by his ubiquitous pipe, and Kissinger is usually represented as no more than a set of thickly framed eyeglasses, his signature attribute.

The story opens in Whittier, California, with the young Nixon in bed, dreaming first of college and later of law school at Duke University. The now enshrined metaphor, used by Nixon throughout his career, of the train tracks alongside his humble childhood home,[25] tracks that would carry him beyond the hardships of the Depression in Southern California to a glorious position in government, appear in the second of these mise en scènes, followed by images of books that suggest his familiarity with the lives of Abraham Lincoln and Woodrow Wilson, two presidents whom he evoked throughout his public life. While *Poor Richard* is wholly a farce, its comedy emanates, partly, from Guston's studied take on Nixon's ongoing self-mythologizing. The allusion to his hard work while at Duke, and the austerity of the cabin, or "clapboard shack"[26] as Nixon described it, which he shared with a few classmates in law school—favorite and recycled anecdotes which he spun into homilies or ser-

mons—are depicted in *Poor Richard* at the outset to play on Nixon's early self-fashioning, and on the disposable morality which quickly informed his political outlook.

From this prelude or background, the book jumps to an image of the young senator and vice-presidential aspirant embroiled in one of many crises: the so-called "Checkers speech" of 1952, in which Nixon would defend himself against allegations of his personal use of campaign contributions through conjuring additional tales that related to his lowly origins. These and the maudlin mention of his dog Checkers (the sole gift he confessed to taking) in his televised denial were some of Nixon's many effective ploys to offset attention from his specious dealings. In *Poor Richard*, Checkers's body is made up of a pattern of uneven squares, evoked elsewhere by the patched and frayed undershirt that Guston has Nixon occasionally wear—another metaphor that italicizes his shabby yet recurring insistence on his innate virtue and modesty. Although the drawings in *Poor Richard* appear as pure jest, they are coded throughout with double-entendre, a dimension that adds to their weight and significance. Guston has inscribed most of these images with some specific historic detail or fact, while capitalizing on the allegory to which Nixon's gambits were naturally lent.

Throughout this brief section that highlights a pivotal crisis or trial[27] in Nixon's early political life, his nose and cheeks continue to expand, stretching into an unmistakably large phallus which becomes emblematic of his growing deceit. Unlike Pinocchio, whose naïveté precluded such (caustic) denigration, and whose nose eventually deflates after admitting to fibbing, Nixon's schnoz becomes in *Poor Richard* an obscene realization of the diminutive of his name Richard, or Dick. The image is clearly sexual; but here, Guston suggests, a nation is being screwed rather than any one individual. Moreover, there is nothing erotic about this engendered nasal projection. Nixon comes across as a first-rate jerk or fool, an incarnation of the common profanity "dick-head." Guston had much to work with in Nixon's nose, given that its morphology or naturally bulbous shape already suggested the male genitalia. Combined with the preexisting phallic overtones of his nick-name, the image doubled the savagery of his condemnation of the president.

The appearance of a television set in one of the drawings from this episode, from which Nixon rants with his scolding finger against those who have questioned his "honesty and integrity,"[28] is also significant. Although a clearly less barbed allusion, it refers to the medium which Nixon will learn to manipulate to gain the presidency in 1968. On a more elusive level, one that functions within Guston's own aesthetic program and career, television is a symbol that alludes to the impotency of abstract painting, the genre he abandoned in 1968, in part because of the content of the news that was carried into his home each evening. Abstraction had become, he felt, simply too disconnected and aloof from world events. While *Poor Richard* is primarily, like Roth's *Our Gang*, a political satire, Guston's thinking about the medium of caricature informed many of the decisions that he had and would subsequently take into his studio, making these metaphors simultaneously more expansive, personal and charged, a stand-in for the predicament of modernist art.

The bulk of the drawings in *Poor Richard* dwell essentially on the build-up to Nixon's first term in the Oval Office and his desire to be linked to and remembered for one specific event—his trip to China, which in August 1971 was still in the making. In the tranquil waters of Key Biscayne, his adored Florida retreat, he is shown plotting his comeback after his failed attempt at becoming president in 1960. Enter Agnew, Kissinger, and Mitchell, whose characters Guston develops through various drawings, expanding on their innate wacky visual possibilities. Agnew, with his pointed cranium, Hawaiian shirt—a reverse take on his always natty attire—and golf clubs, becomes a perfect parody of his notoriously dim-witted public statements. While Kissinger, ever the set of black glasses, is in one image coupled with Nixon's floating colossal nose, a pairing which points to his status as the soon to be president's closest adviser.

The 1968 election which eventually placed Nixon in Washington is traced through a long sequence of foreboding scenes in *Poor Richard*, the first of which finds Mitchell, as campaign manager, with a pipe emitting an ominous cloud of black smoke, orchestrating a series of "photo-ops" for the presidential want to be. Nixon is depicted in three drawings in front of a camera courting various underpowered voters, such as the black, old-age and youth commu-

nities, with increasing degrees of disingenuousness. A racist stereotype of a little black girl with wide eyes and enlarged lips is recirculated here along with the cliché of a hippie and "mom and pop" types to underscore what Guston perceives to be the insincerity of Nixon's interests. Nixon looks more alarmed by the lurid graffiti which he encounters in a latrine than by any disenfranchised group or national event, a reaction which is also suggestive of his moral rigidity. In the next sequence, he visits his spiritual adviser, Billy Graham (who is also sardonically recast as the Reverend Billy Cupcake in *Our Gang*), and appears as a keystone cop or ludicrous arbiter of religious standards.

Guston's belief in the falsity of Nixon's political moves, and the contradictions posed by his Christian values, engendered a number of drawings for *Poor Richard* in which Nixon and his kitchen Cabinet are masked and hooded to resemble the Ku Klux Klan, an image which had surfaced in his painting around 1968. Nixon may have refashioned himself as "the new Nixon" in the 1968 election, with the acclaimed objective as president "to bring the American people together"[29] and to end the Vietnam War, but through Guston, Nixon and his cronies, as Klansmen, become personifications of evil. In two particularly scathing drawings, the orifices of Nixon's and Agnew's Klan outfits open into the shape of a toilet, a clear intimation of Guston's view of the content of their public discourse.

Of course, the presidential race ends to Nixon's advantage, and in *Poor Richard* the disguises or Klan dresses are cast into a garbage can, no longer needed. The narrative breaks again and suddenly Kissinger is on his way to and from China. While the national security adviser had taken one secret mission to Beijing in mid-July of 1971,[30] which Nixon subsequently reported in a televised address as laying the groundwork for "his journey of peace,"[31] the president did not make the actual trip until late February 1972, long after *Poor Richard* had been finished. Guston's drawings that relate to this historic event are purely imaginative then. Nonetheless, 1971 was a pre-election year, and Nixon not only longed for reappointment but also a distinctive achievement which would imprint his stint at the White House. And Guston saw in Nixon's efforts to effect a rapprochement with China in 1971 what he considered to

be one of his most patent hypocrisies. For, in this last rambling set of drawings, Nixon is shown no longer mindful of Communism, the menace he had once decried as an international threat. However rabid he had been on the subject, invoking its tyranny in the late 1940s to incriminate Alger Hiss and later in the mid-1950s to back Joe McCarthy's purge of intellectuals and artists associated with the Party, his anti-Communist sentiment dissipated and the trip to China could only be grasped by Guston, as by Roth, as blatant self-interest.

Beneath an imperious dragon, and later a suspended hatchet, Nixon is depicted by Guston scheming and frolicking at his oceanside retreat, with no recall of the specter of Communism. He is too busy forming his "Asian Tour," which unfolds as a ballgame, with Nixon in a tank top and hard hat in his role as coach, issuing orders to Agnew and Mitchell in a mock Chinese script. The black vote, which he once feebly courted, is baffled and angry in one caustic scene, in which his Chinese euphoria meets with outright contempt and estrangement.

The sports metaphor here recalls a topical news story—the visit of the American Table Tennis team to Beijing in the spring of 1971 (the first such invitation extended from the People's Republic of China). The ping-pong players' trip occasioned one of Agnew's infamous public gaffs: he admonished reporters for their benevolent assessments of Chinese life, claiming their coverage "was a propaganda triumph."[32] The episode is reenacted in *Poor Richard* in a drawing in which Nixon rails against Agnew for his clumsy blunder (Agnew would earn the epithet "bull in a China shop"[33]). But Agnew's lack of diplomacy is counterbalanced by the presidential team's dreams of glorification, of being deified and carved into the slopes of Mount Rushmore, as Guston fixes Nixon, Agnew, and Kissinger in one cutting image here. He collapses their sense of expectation, though, in a companion scene through the representation of a flimsy wooden scaffolding which supports two flimsy cardboard profiles of the president and his sidekick. At the end of *Poor Richard*, Nixon and his team emerge as rubble, as broken sculpted heads, not unlike Greek statuary, or the fragments of an elapsed civilization (another double-entendre or veiled reference to the demise of modernism). Eventually, these relics are tossed into toilets and garbage cans, a sneering prediction of Nixon's dubious fate, and the president and his Cabinet are remembered merely as a "Kissinger Pot Pie," "Spiro Sponge Cake," and "Nixon Cookie."

But before this denouement, the fictitious trip to China finally takes place. Guston has Agnew and Kissinger take part in the venture (Agnew actually ended up staying in Washington), sightseeing with the president at various pagodas and the Forbidden City in rickshaws and an archaic car. Nixon's etiquette and protocol lapse in two momentous scenes in which he dispenses with his chopsticks at dinner, finding his schnoz a more expedient implement. This is a comedown from an earlier drawing in which he dons a Fu Manchu mustache and braid, a shaded allusion to his misplayed political options, while China's military aggression looms large at the end of *Poor Richard*, and the Vietnam War, student unrest, the ghettos and poverty remain literally out of the picture, concealed off-stage, where Nixon, Guston suggests, deemed they should be.

Poor Richard is a remarkably prescient satire, forecasting Nixon's demise three years before his resignation after Watergate. Of course, Nixon's negotiations with China would later be construed by many historians and political analysts as his great work of statesmanship (rewarded with a Nobel Prize), a successful easing of China's forty-year political standoff with the West as well as a strategic step towards halting the war in Vietnam. But these accomplishments notwithstanding, in the duplicity of Nixon's motives up until 1971, Guston, like Roth, found plenty of material to divine his end.

PART TWO OF THIS ESSAY BEGINS ON PAGE 91

"It seems like an impossible dream"...

Presidential Nomination Acceptance Speech
Republican National Convention
Miami Beach, Florida
Thursday, August 8, 1968

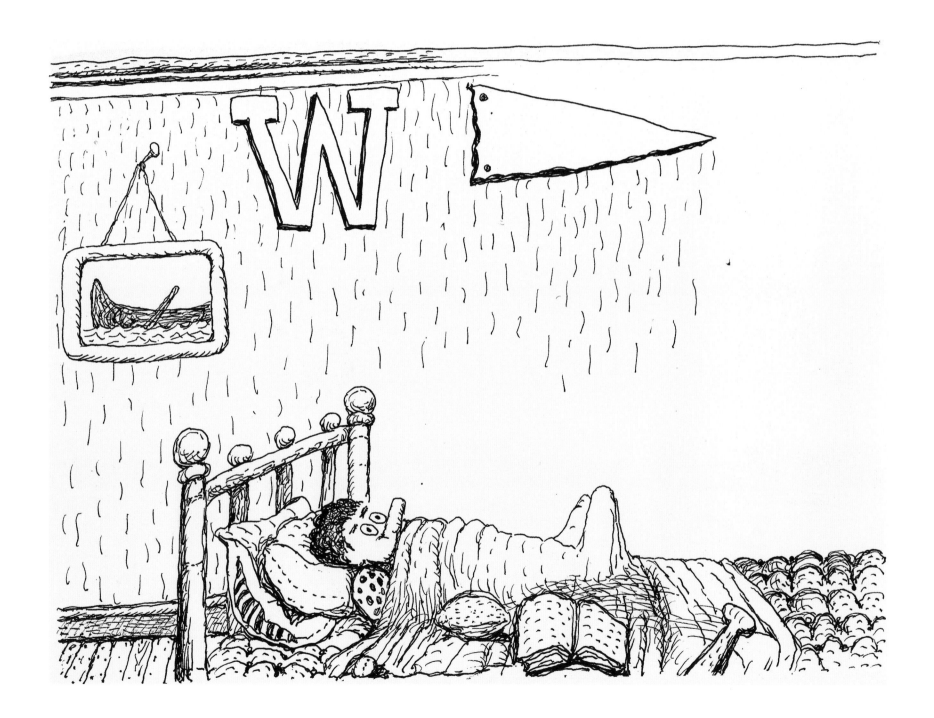

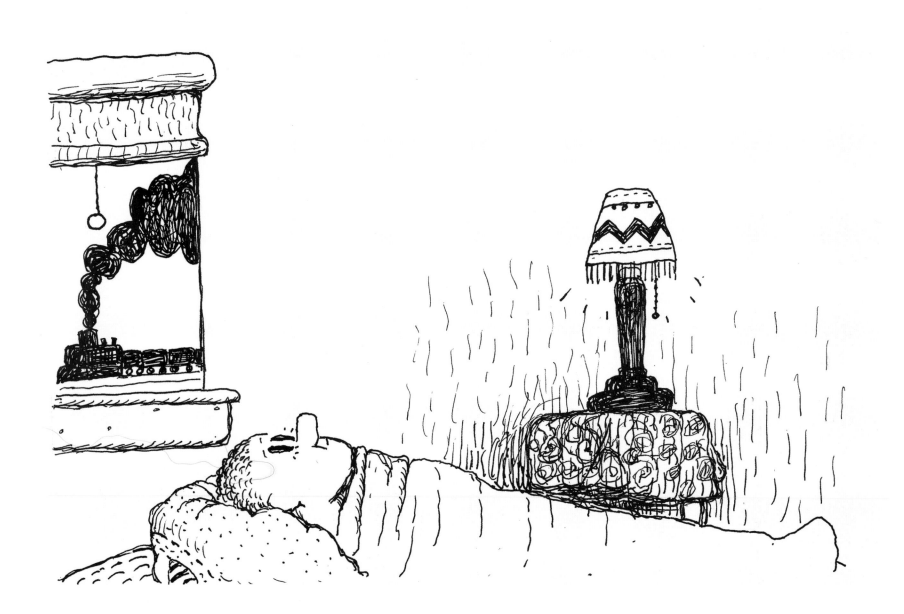

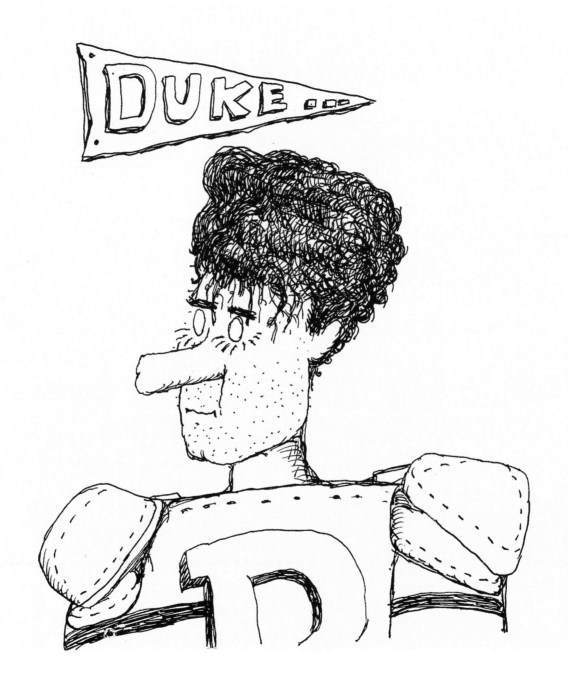

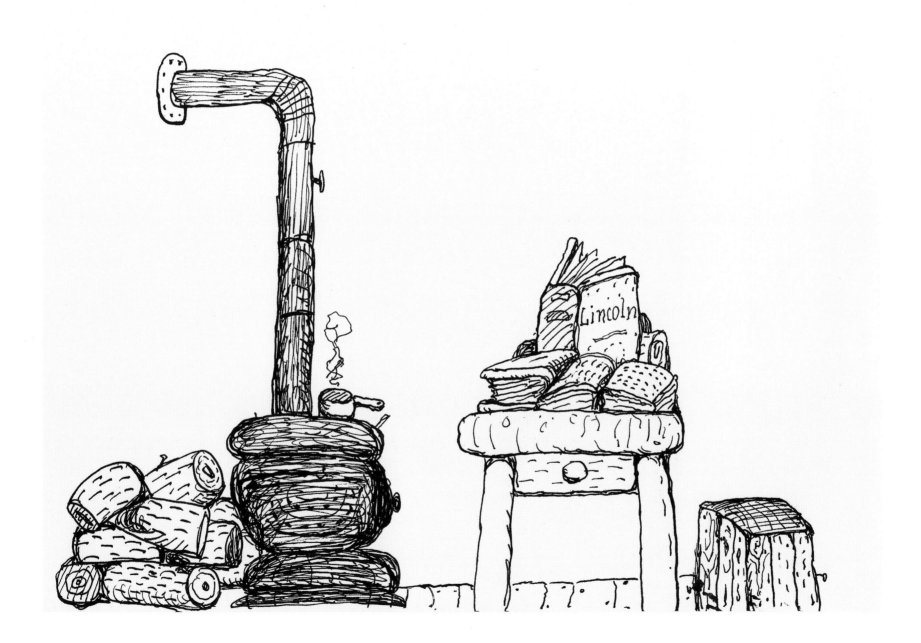

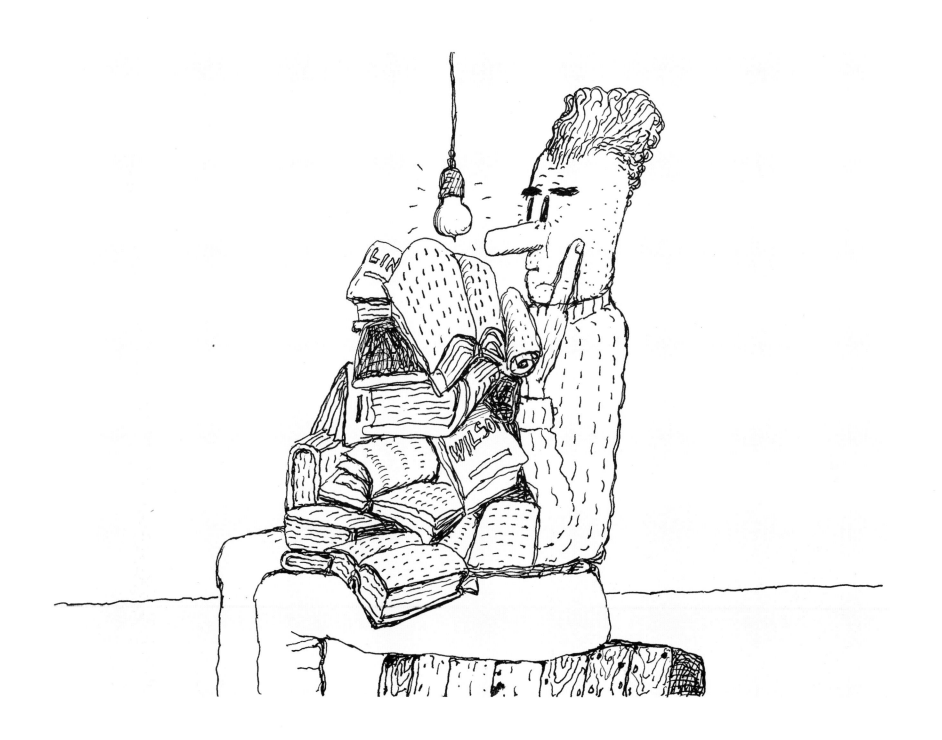

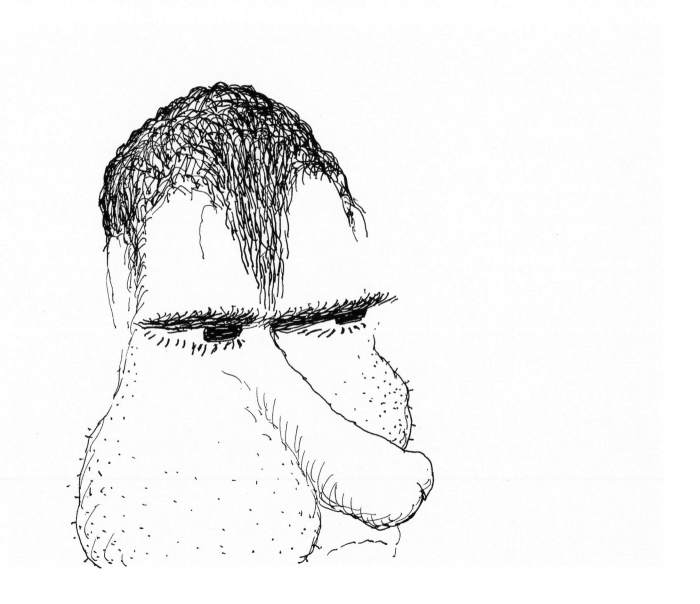

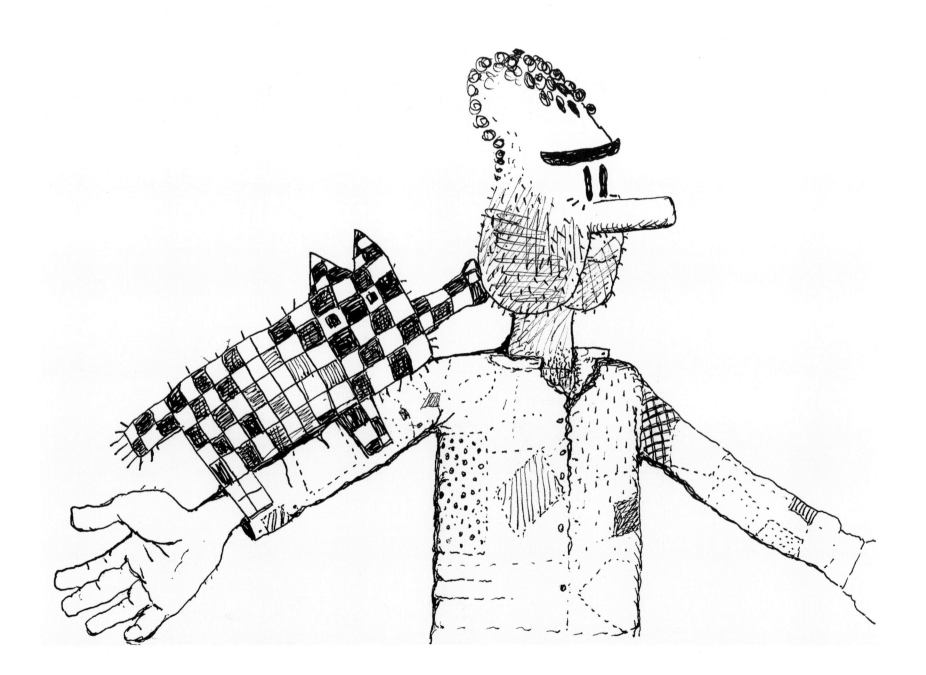

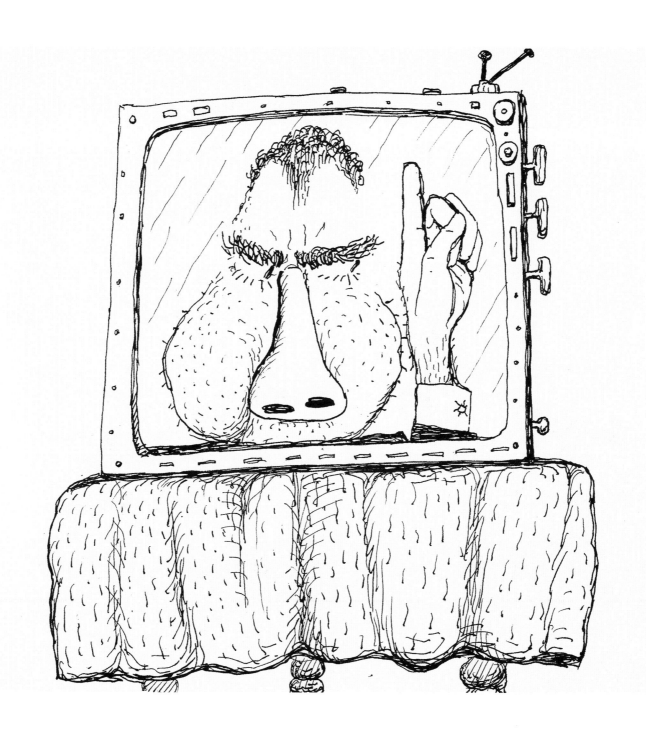

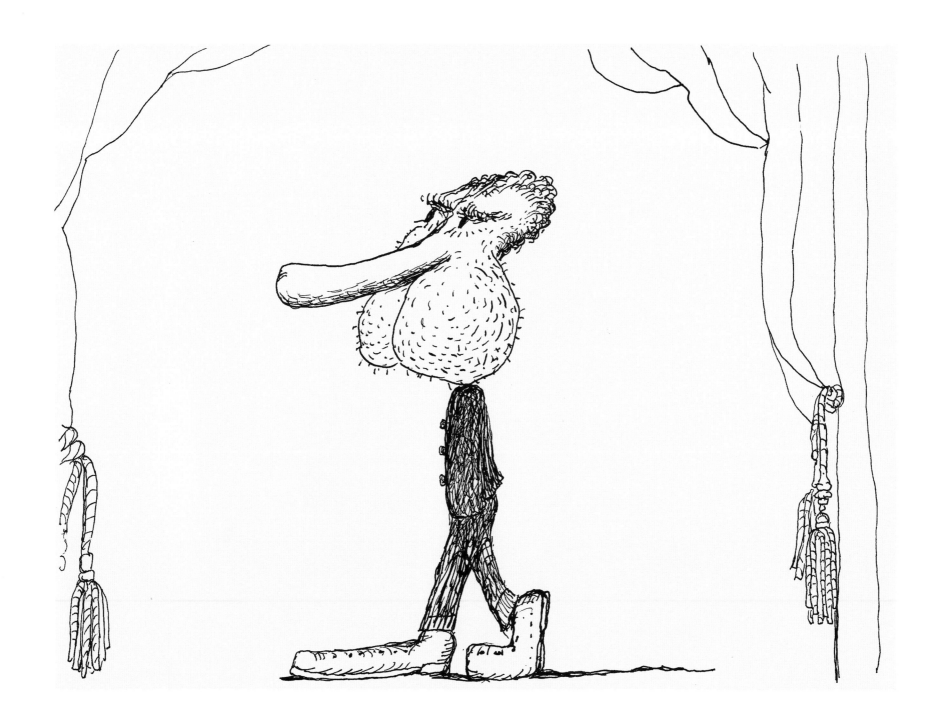

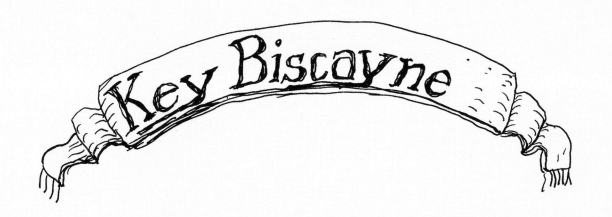

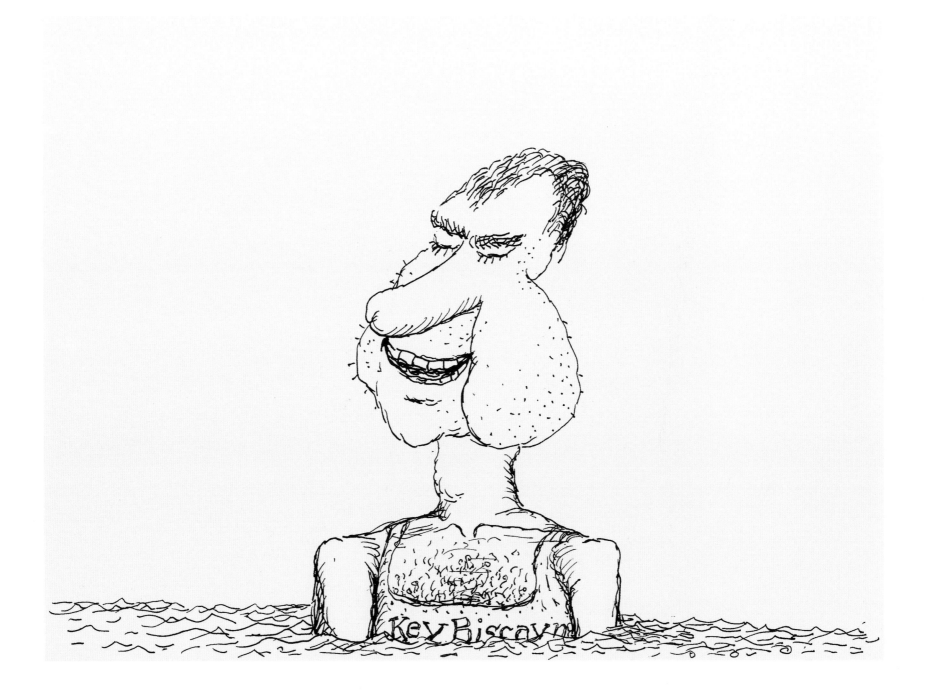

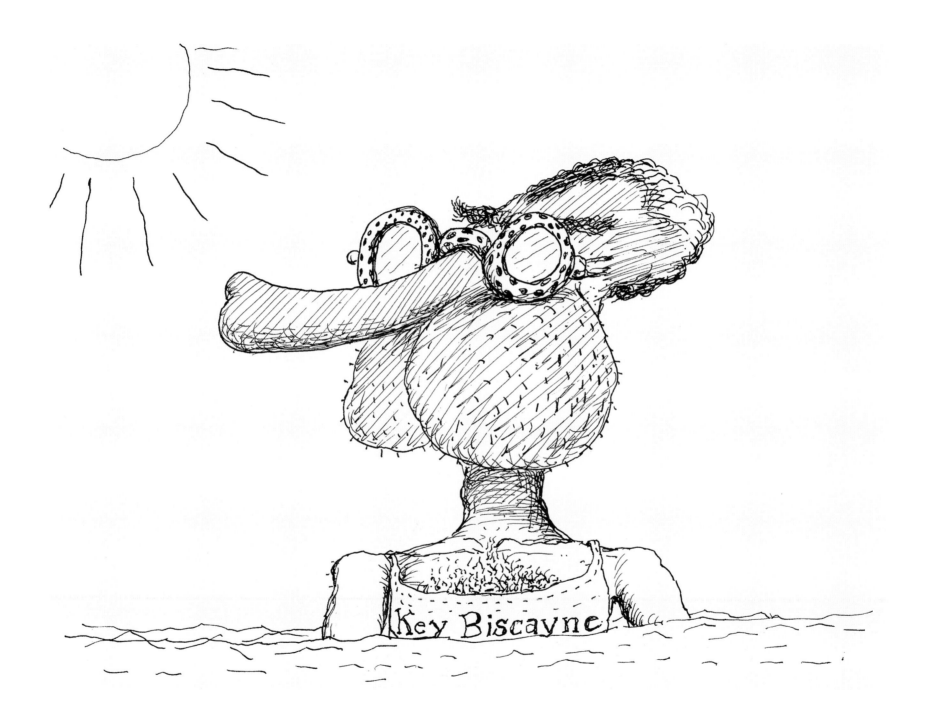

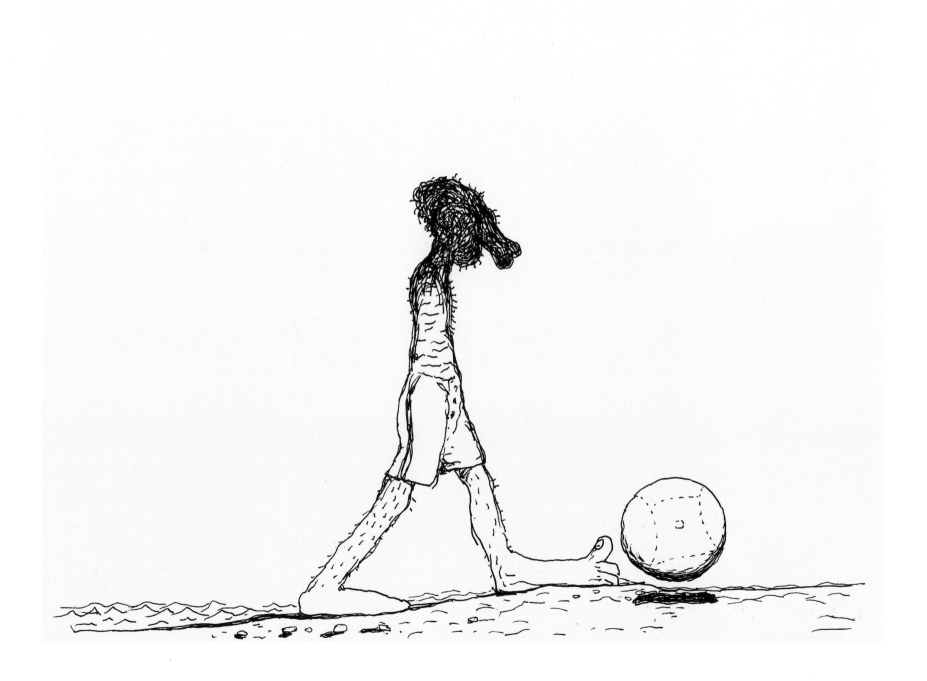

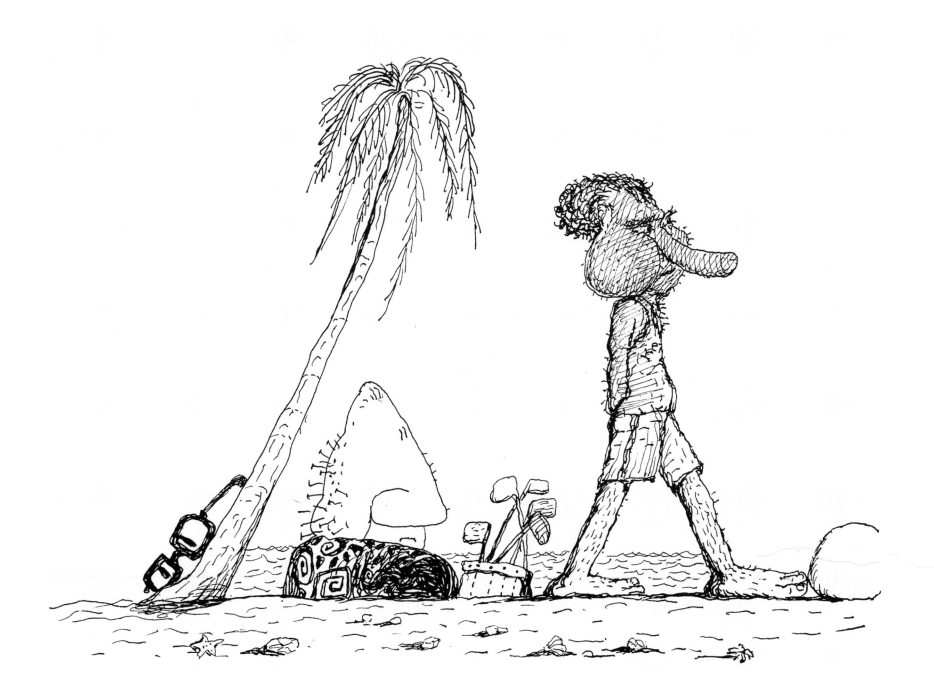

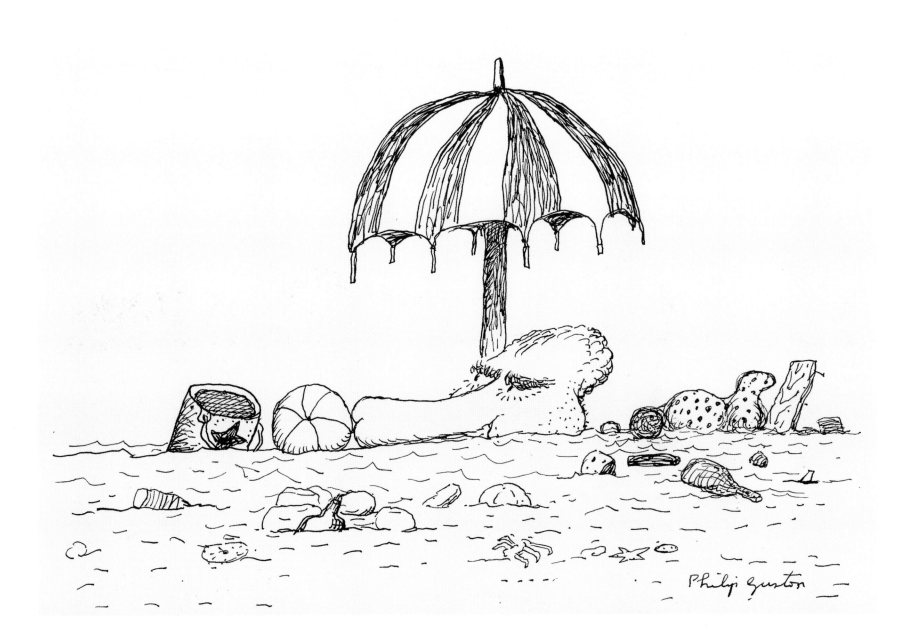

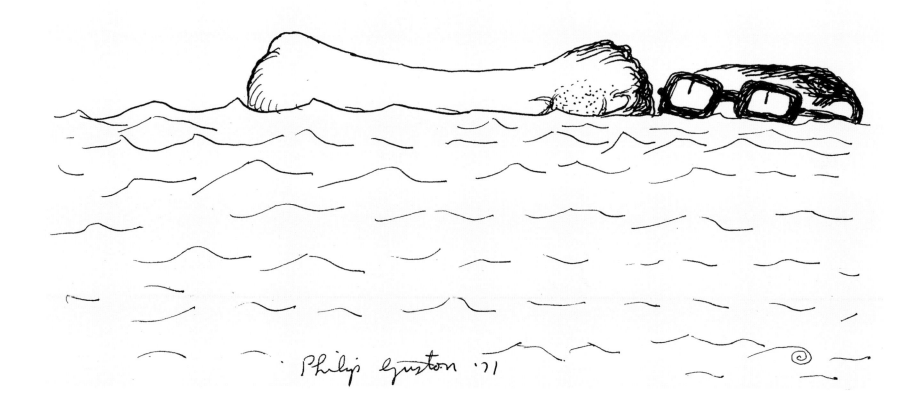

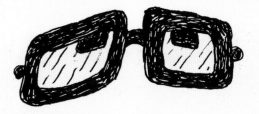

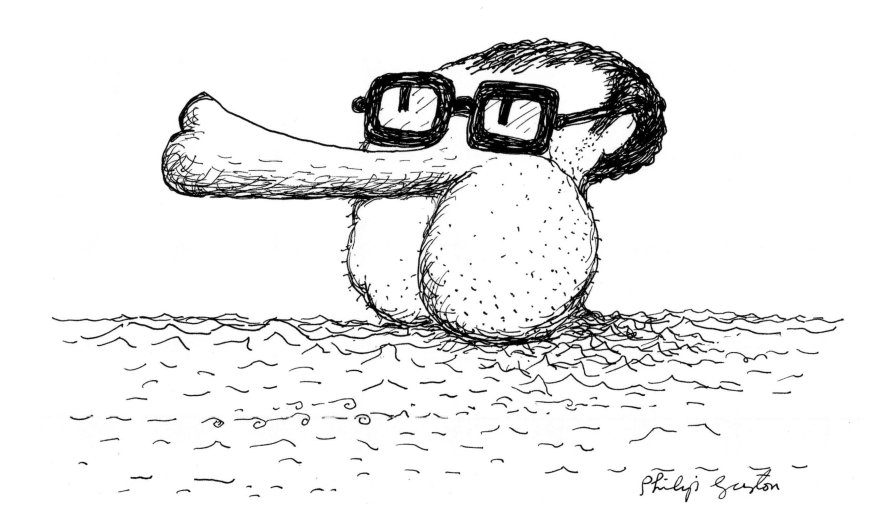

Philip Guston

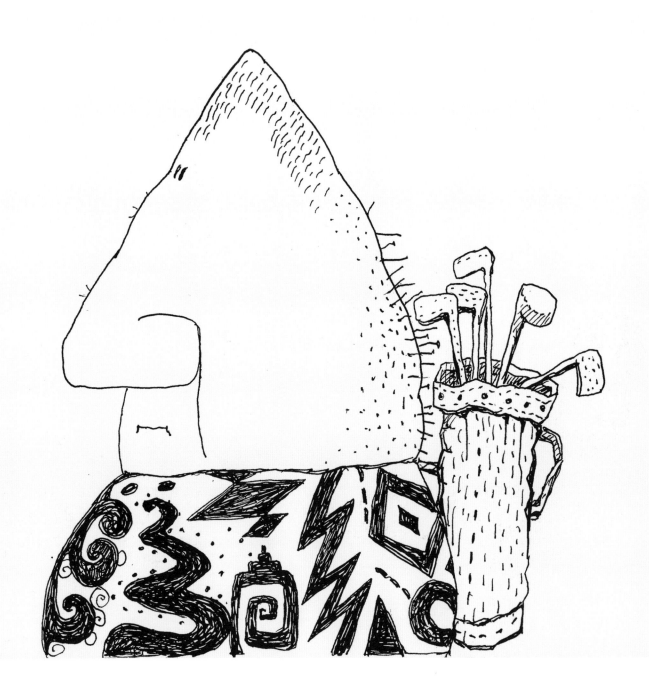

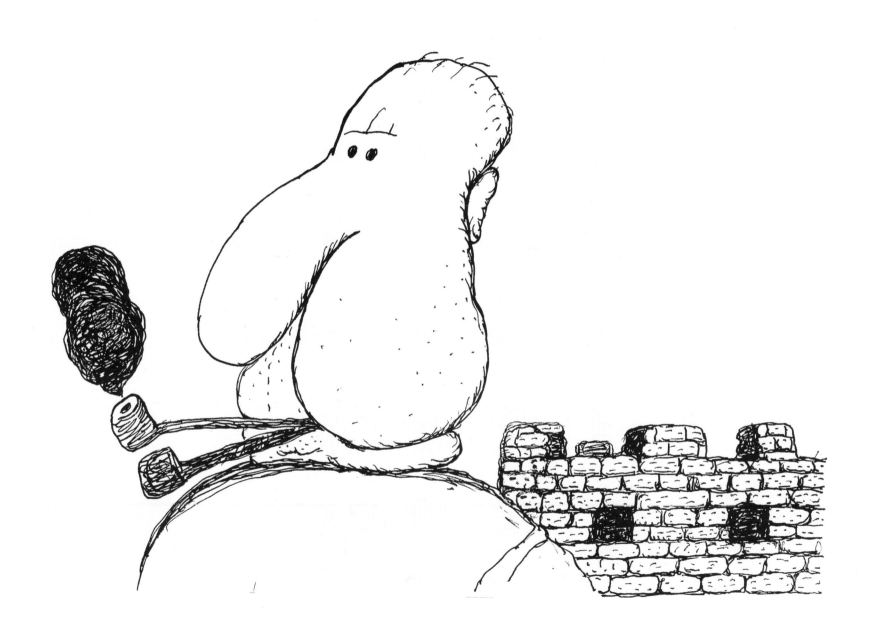

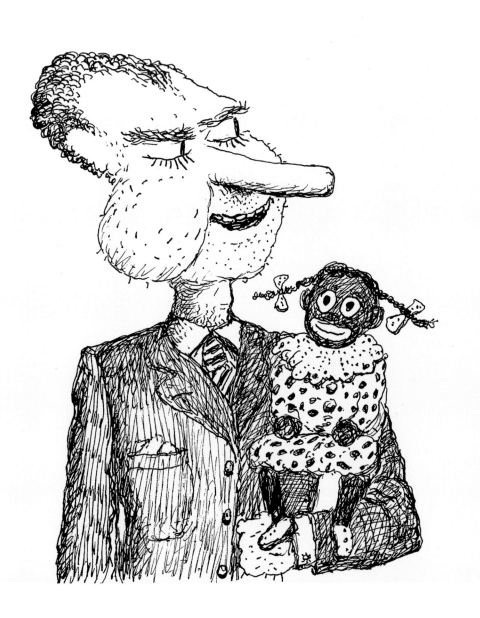

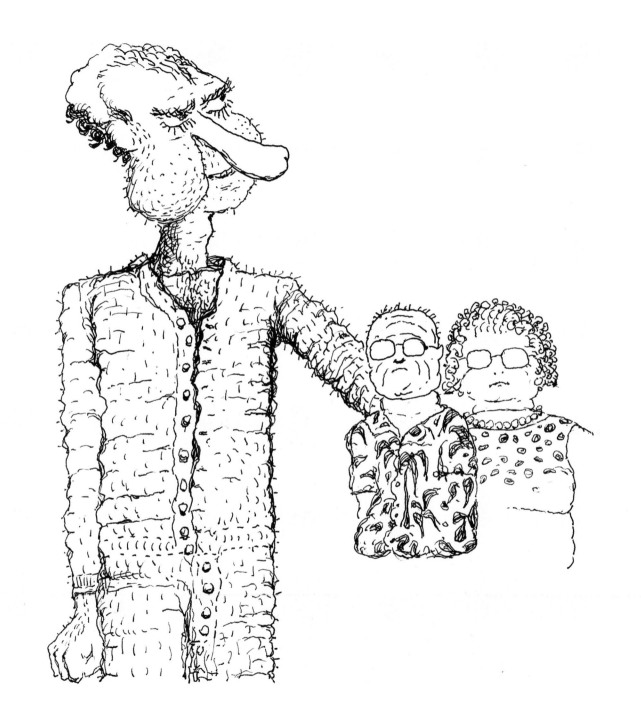

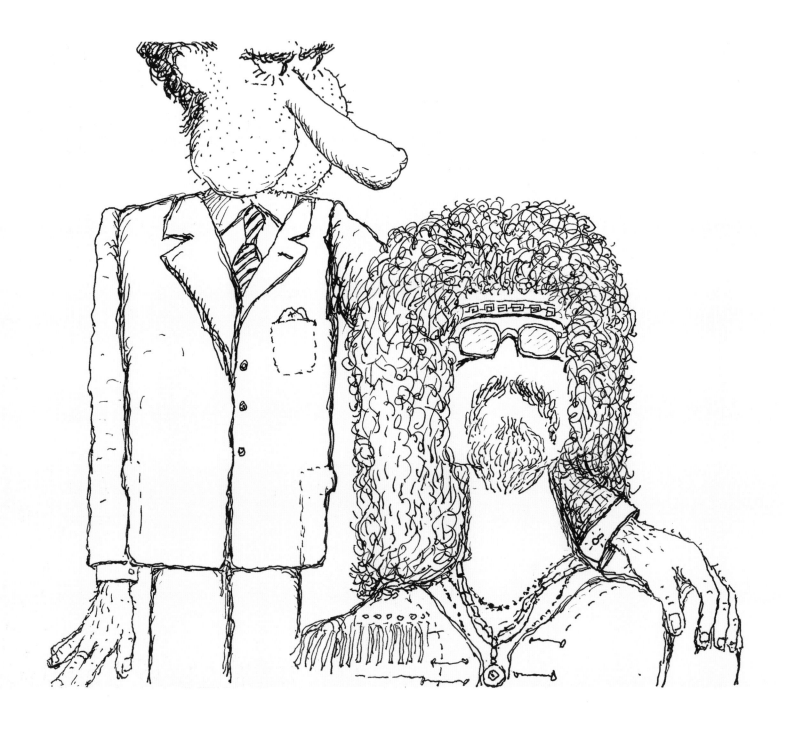

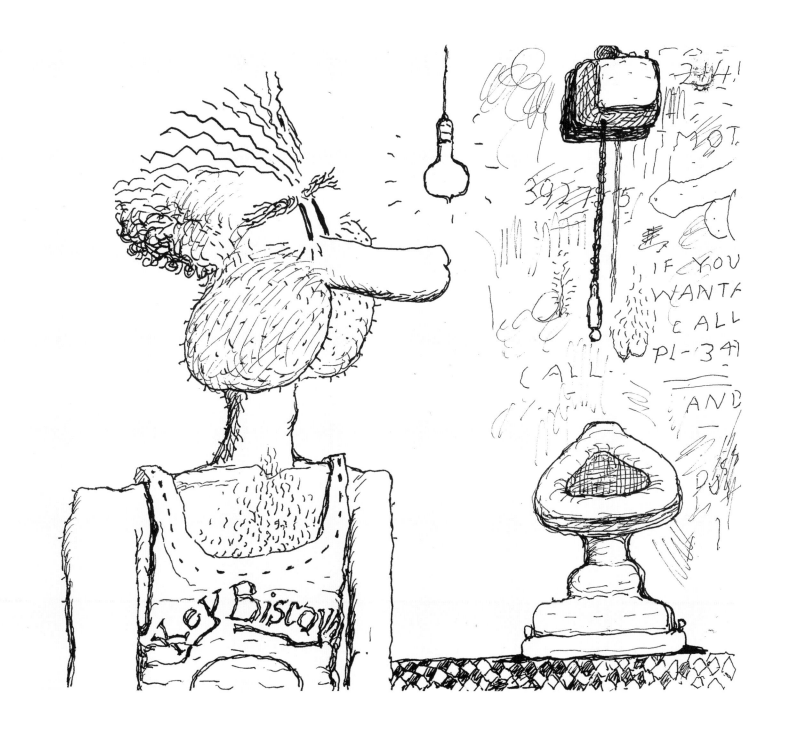

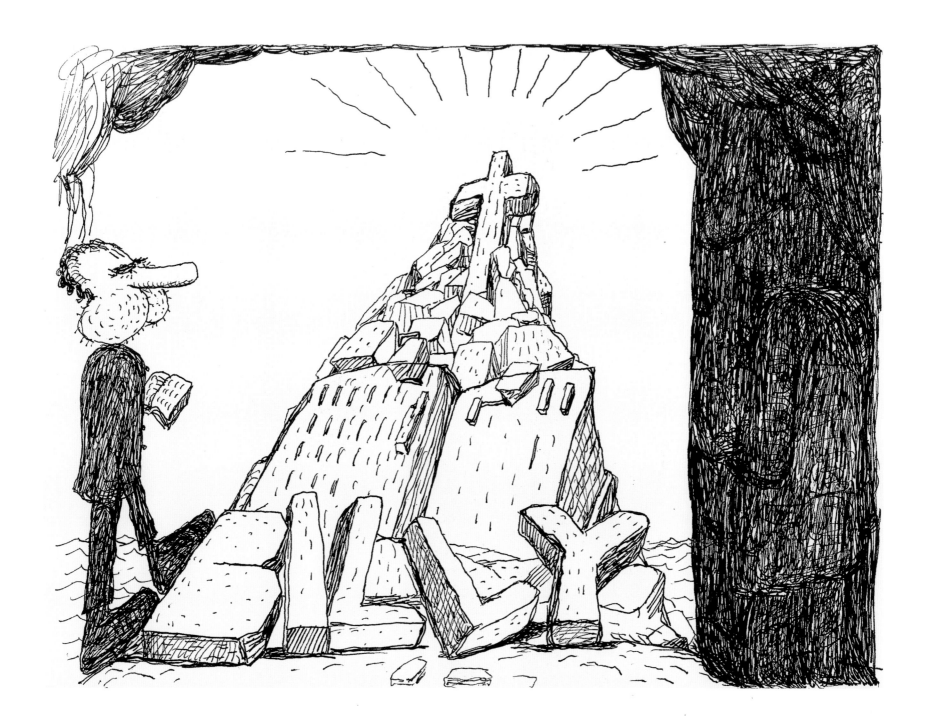

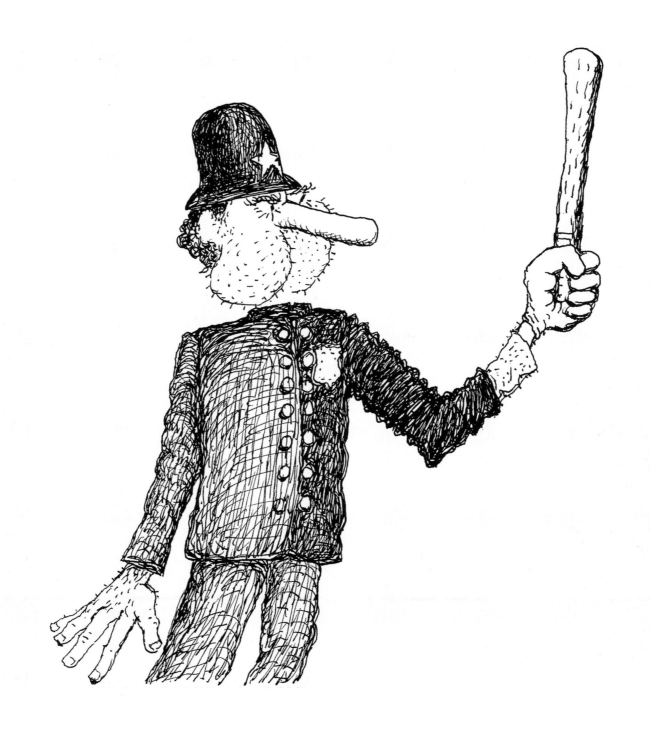

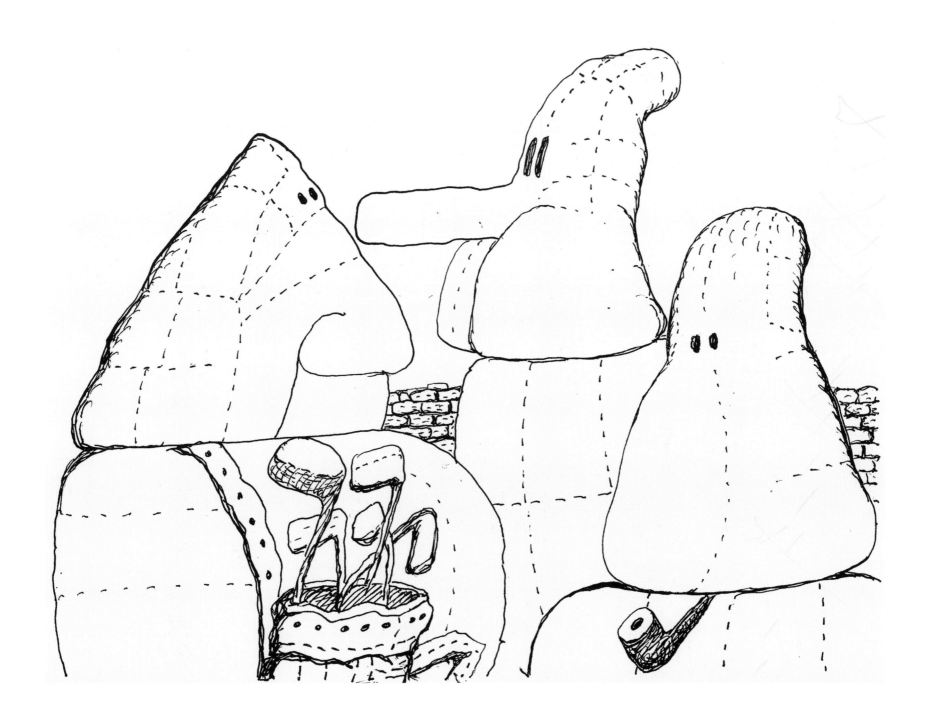

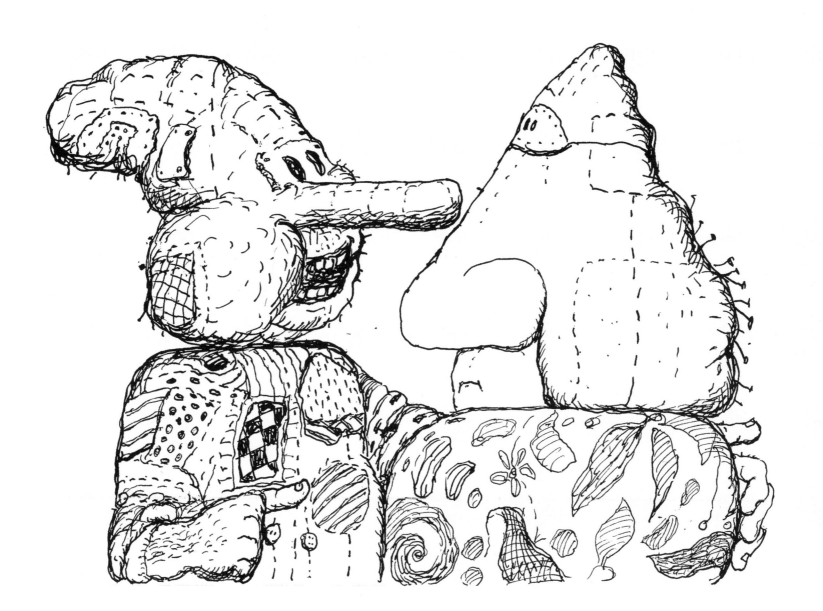

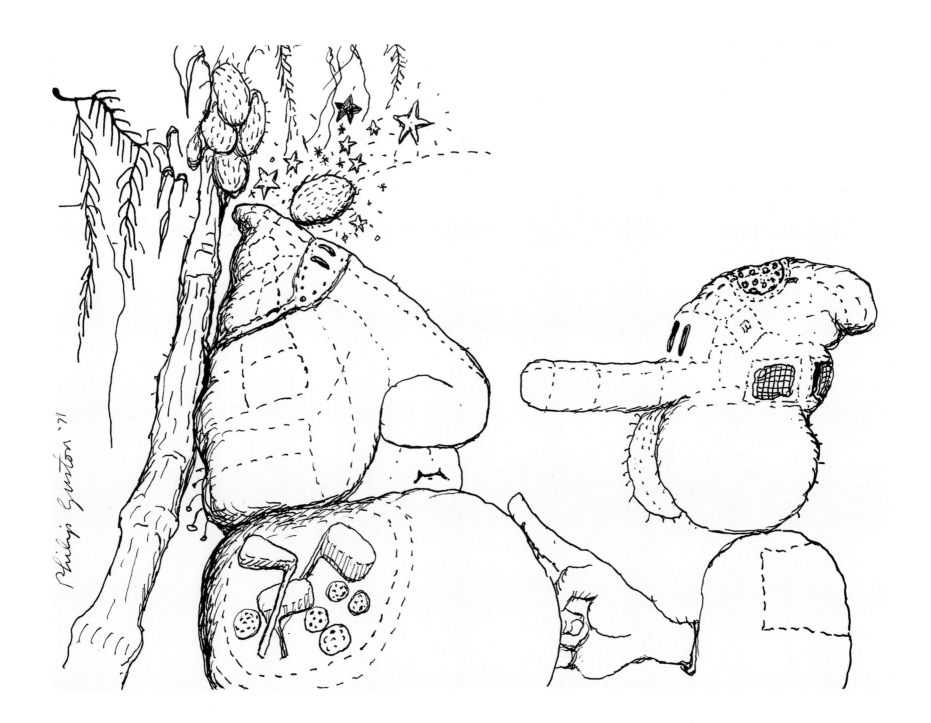

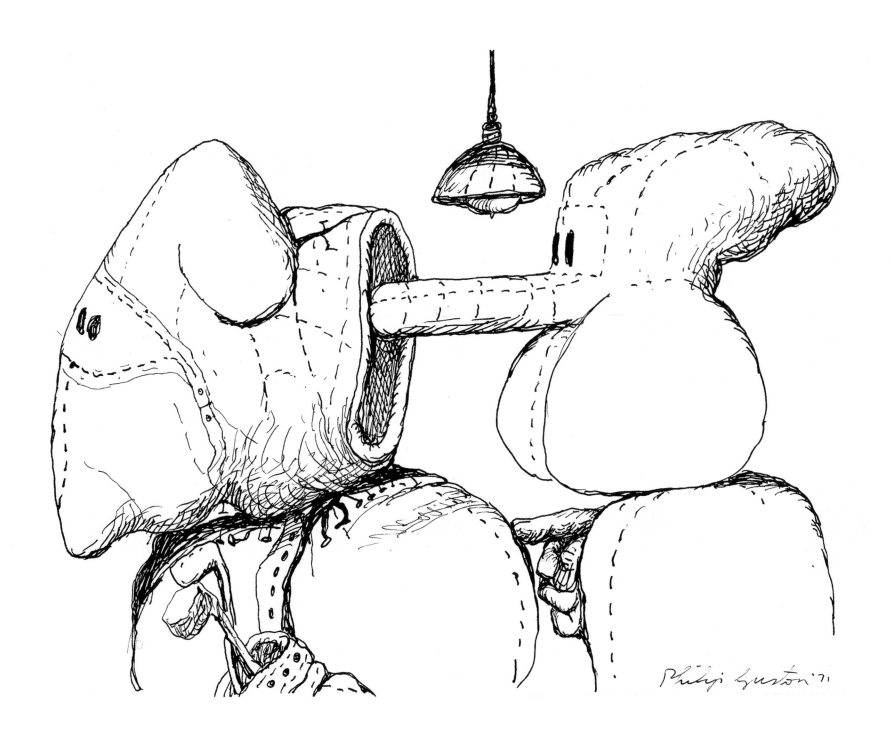

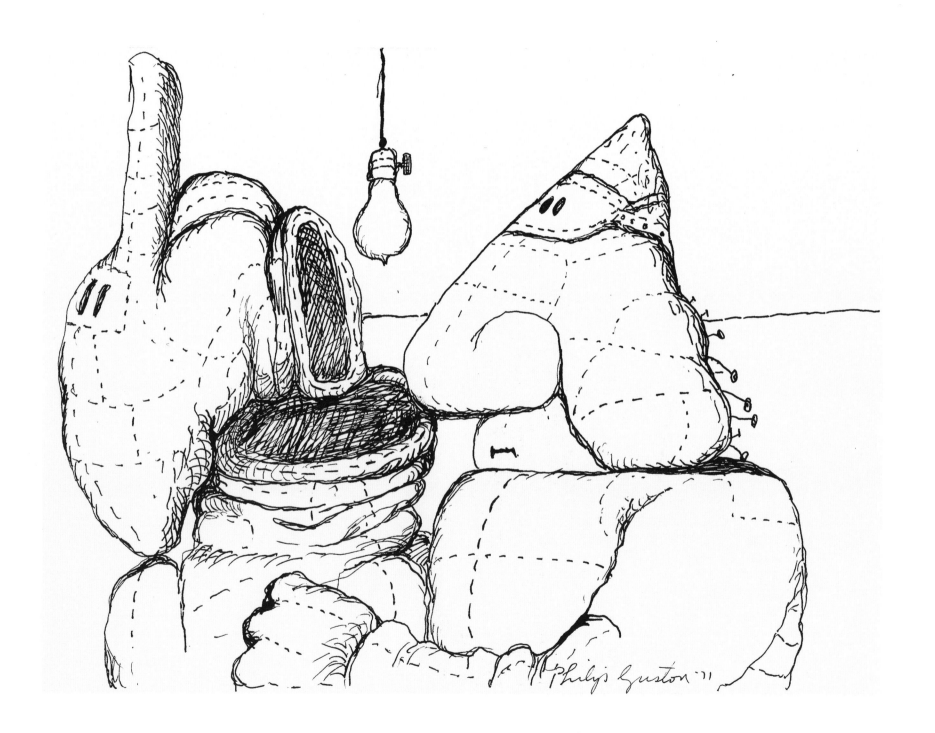

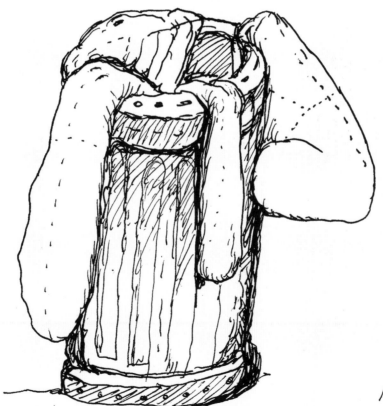

Philip Guston '71

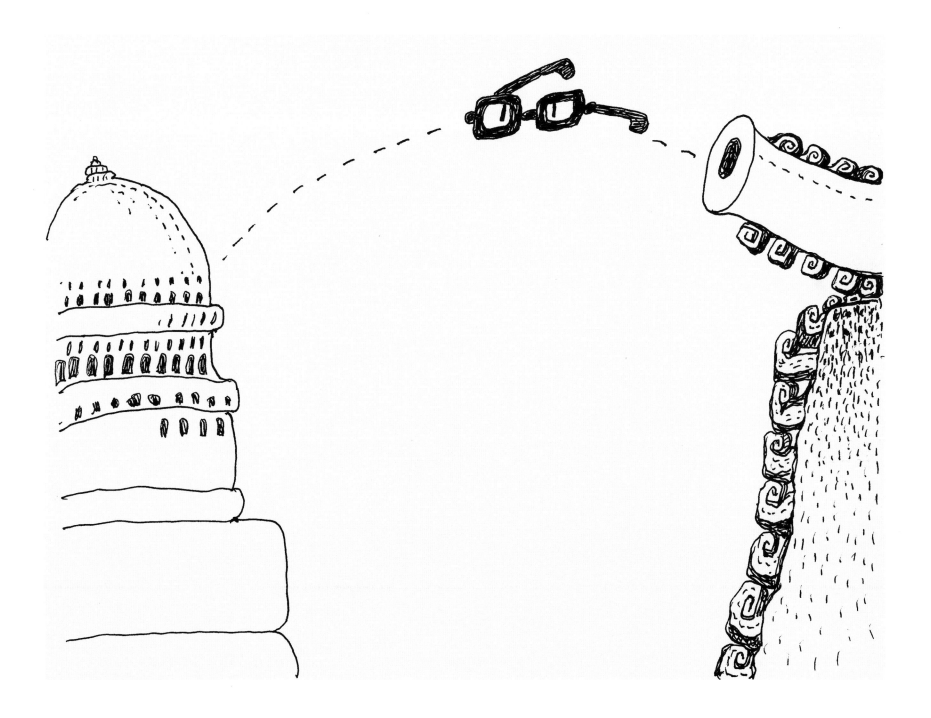

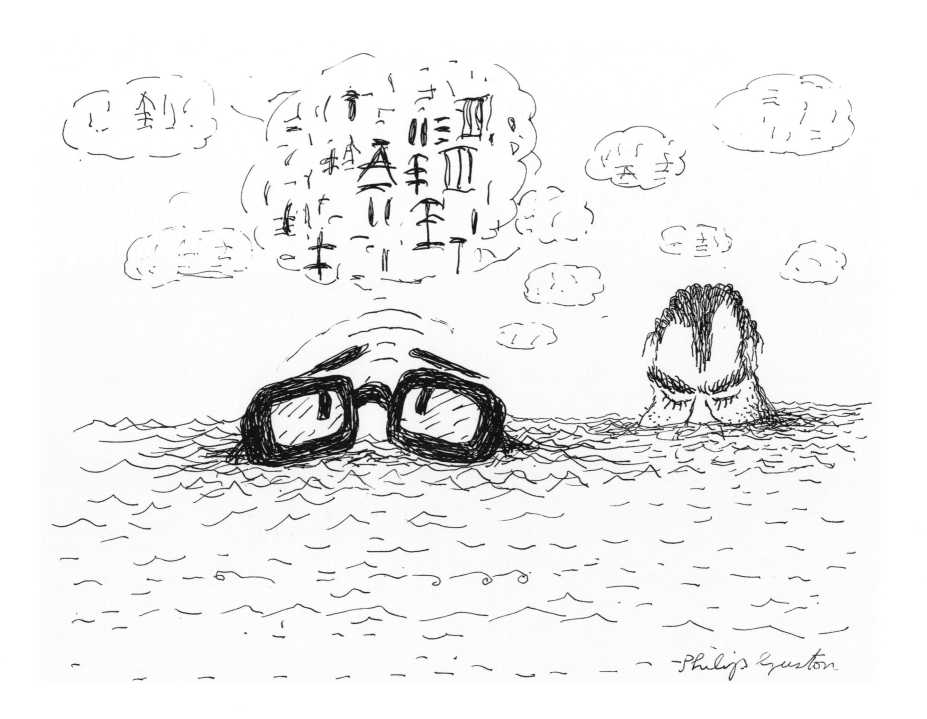

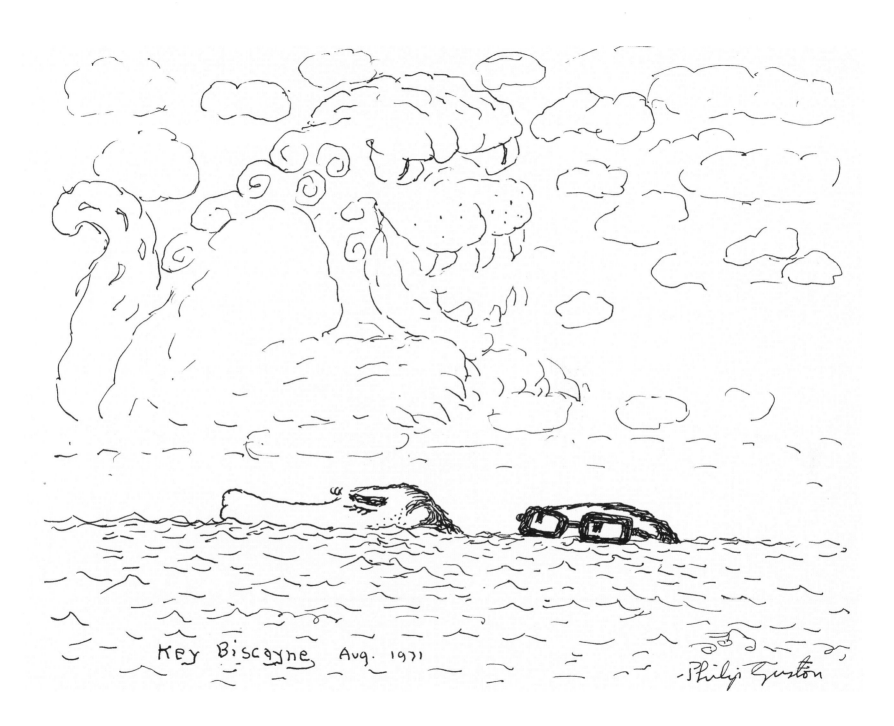

Key Biscayne Aug. 1971

Philip Guston

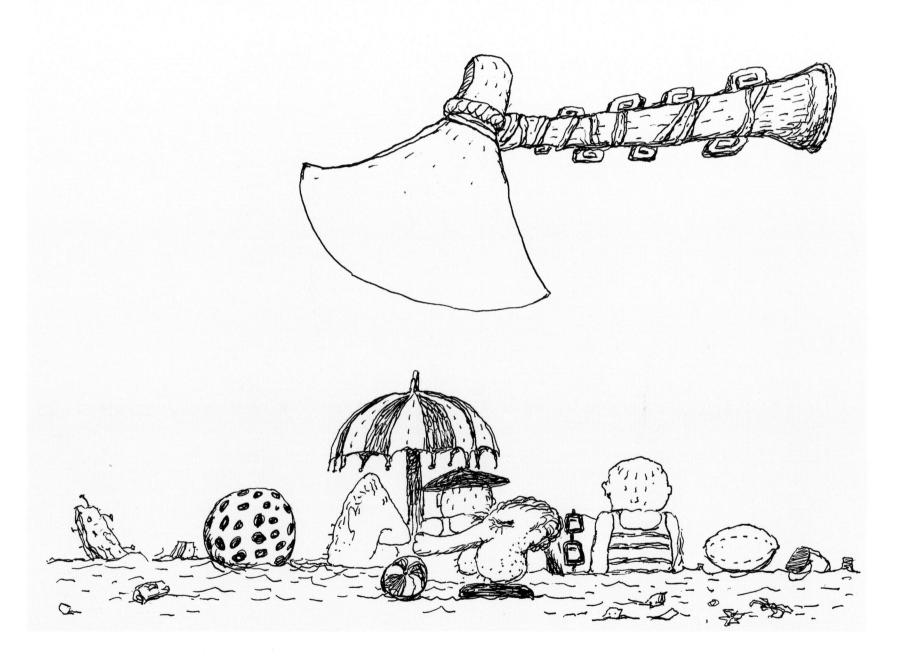

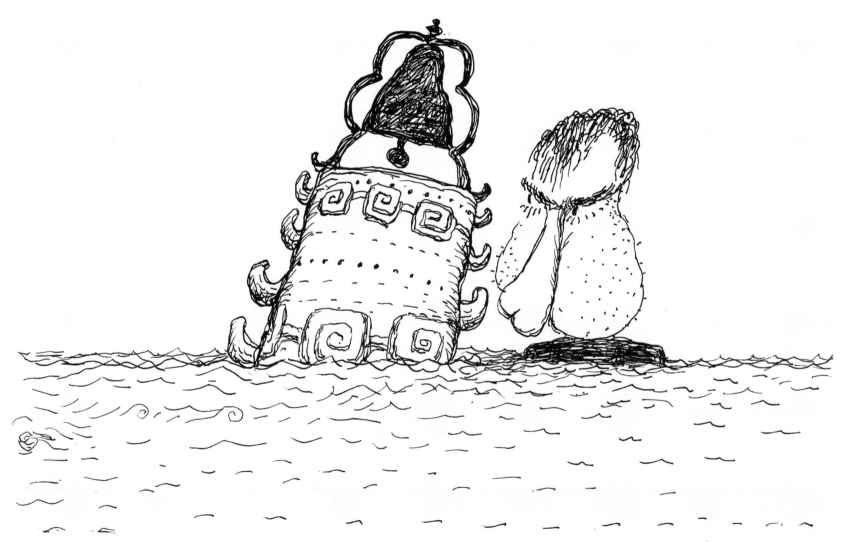

Philip Guston '71

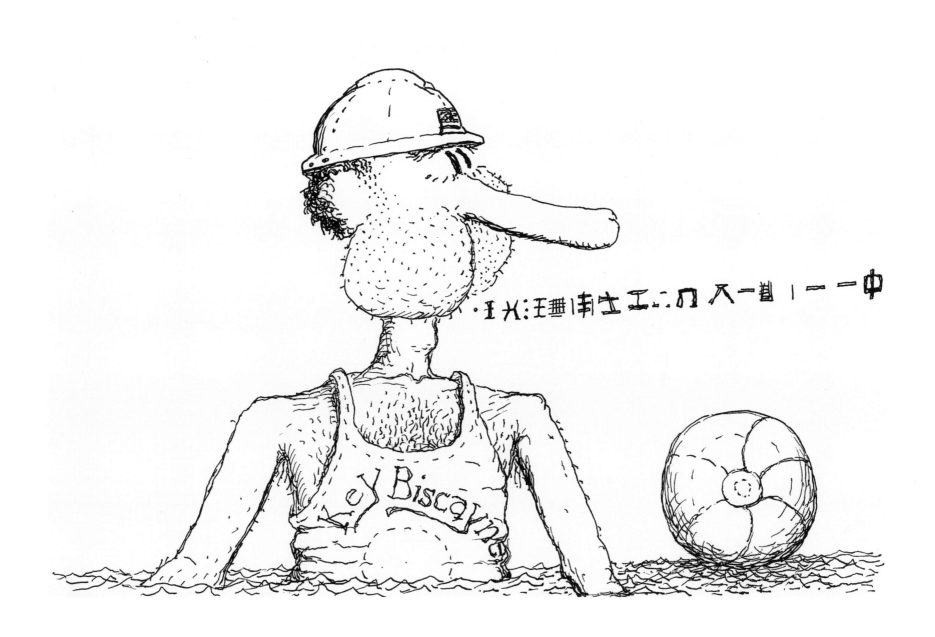

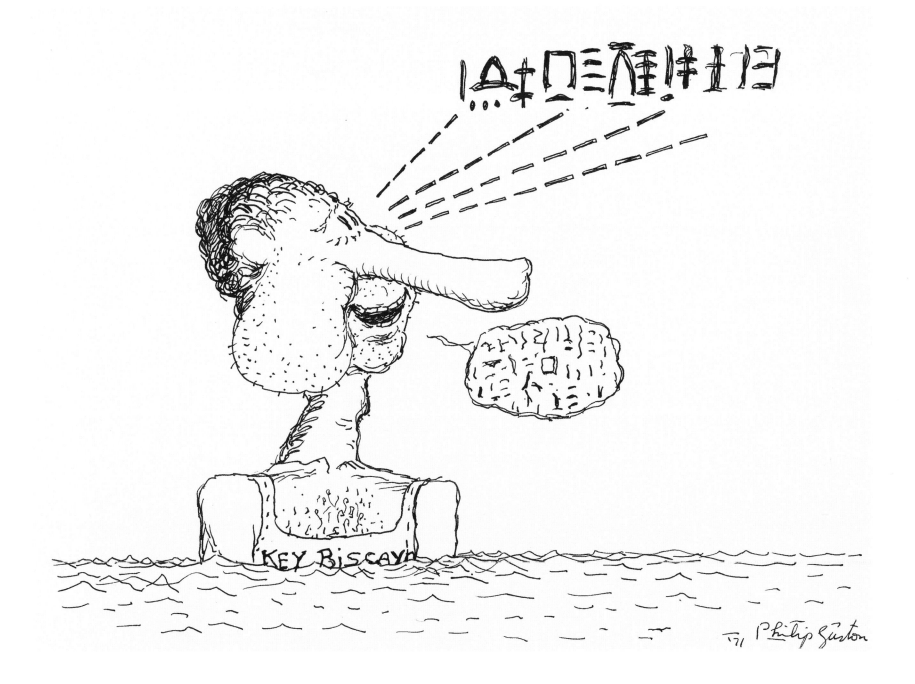

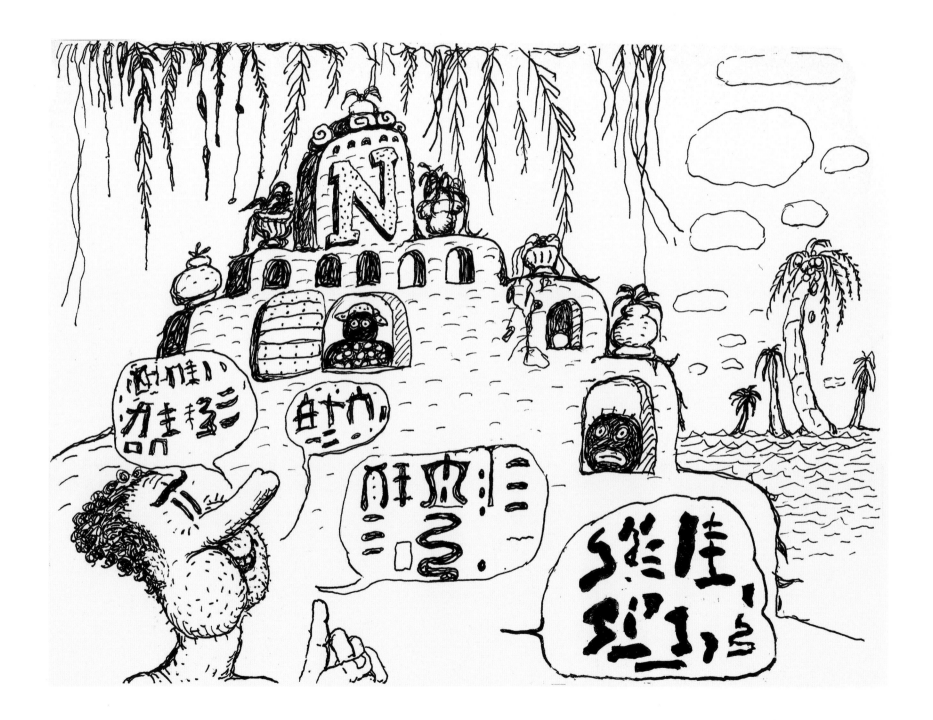

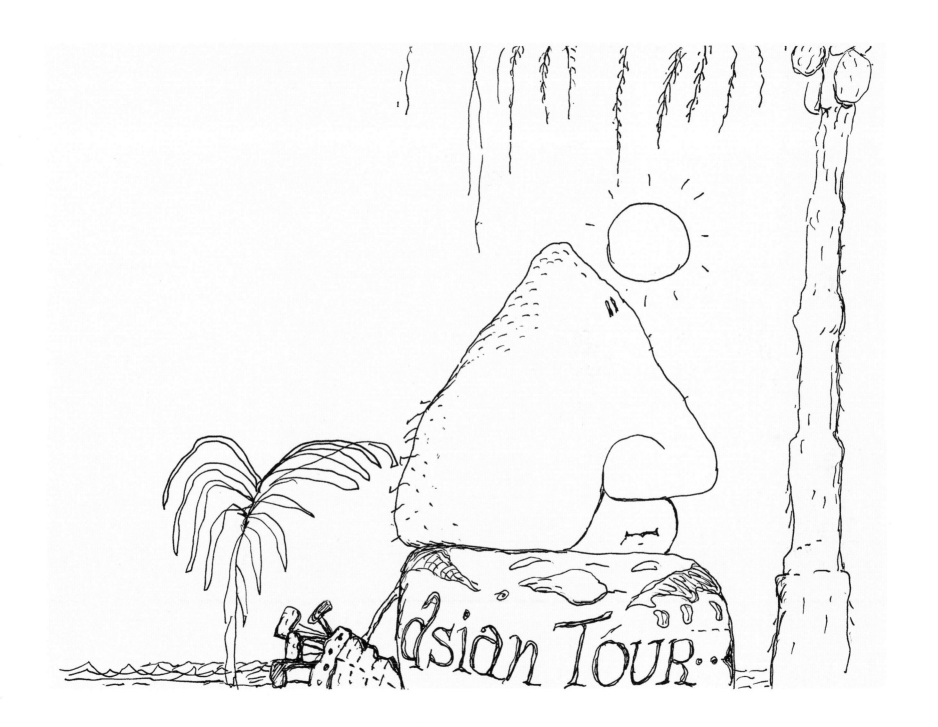

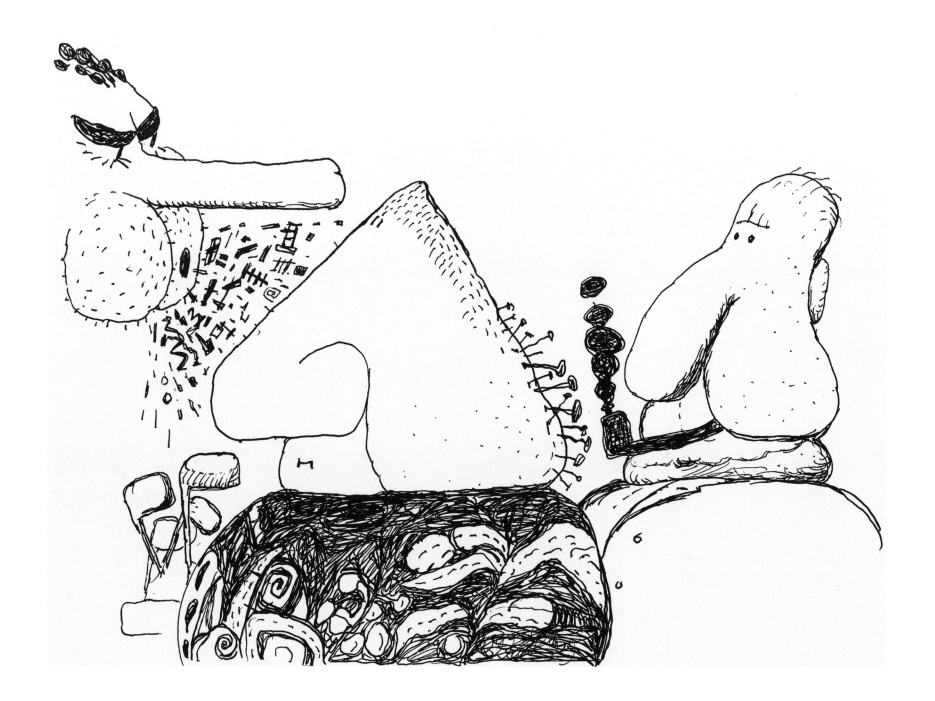

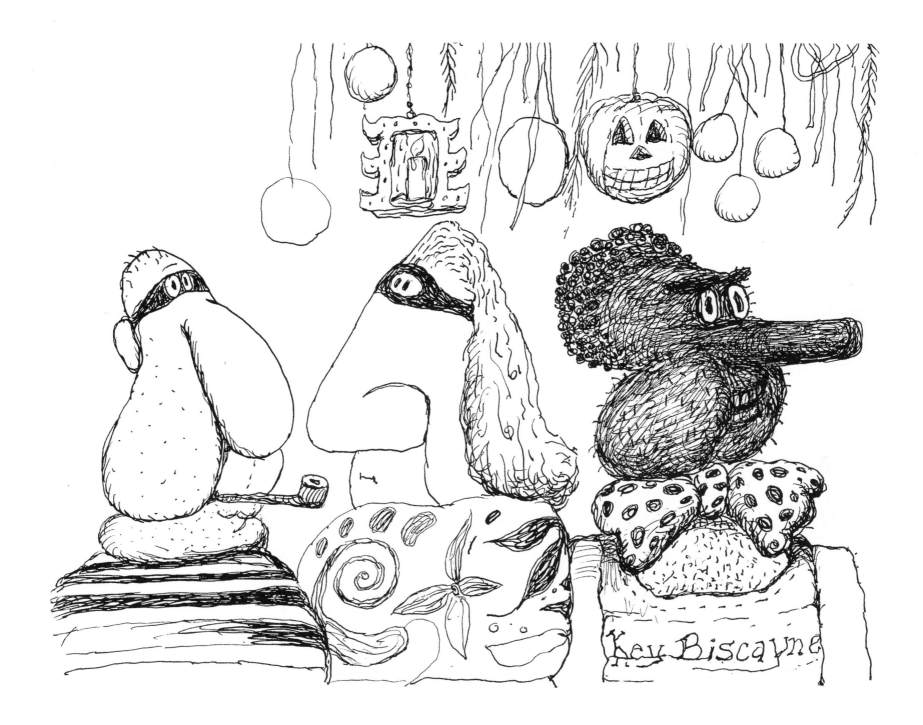

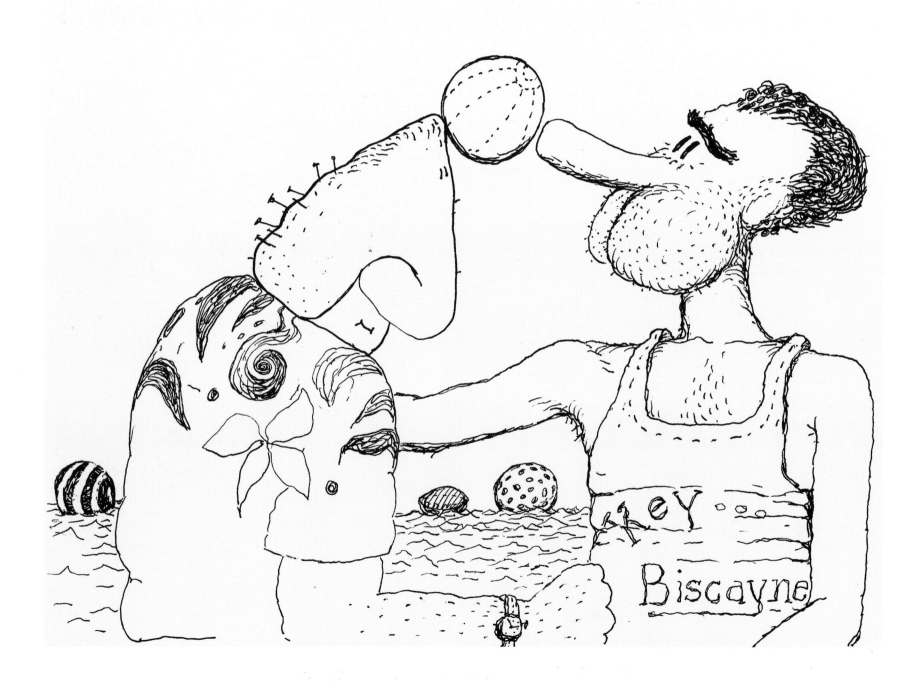

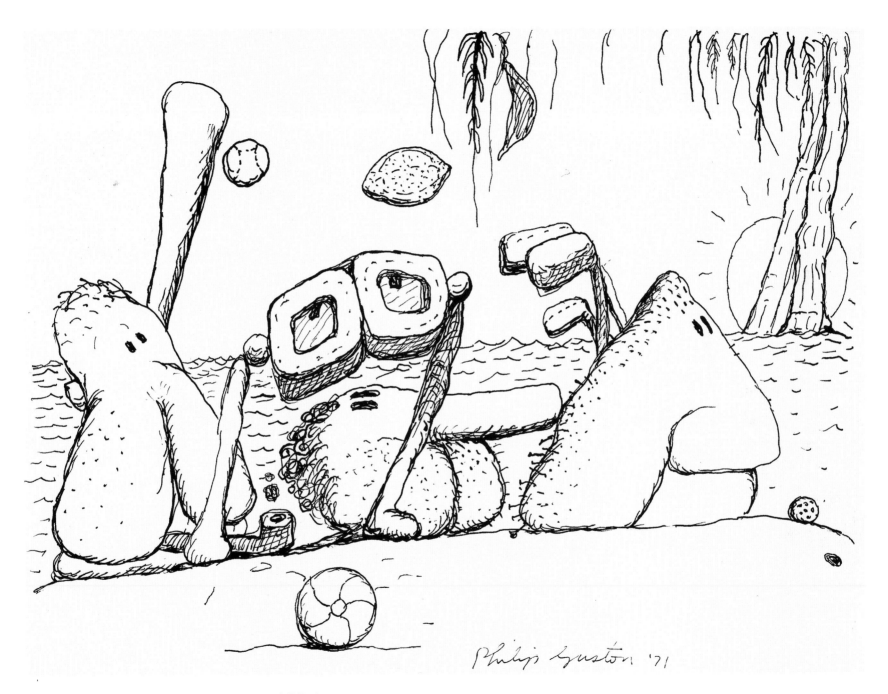

Philip Guston '71

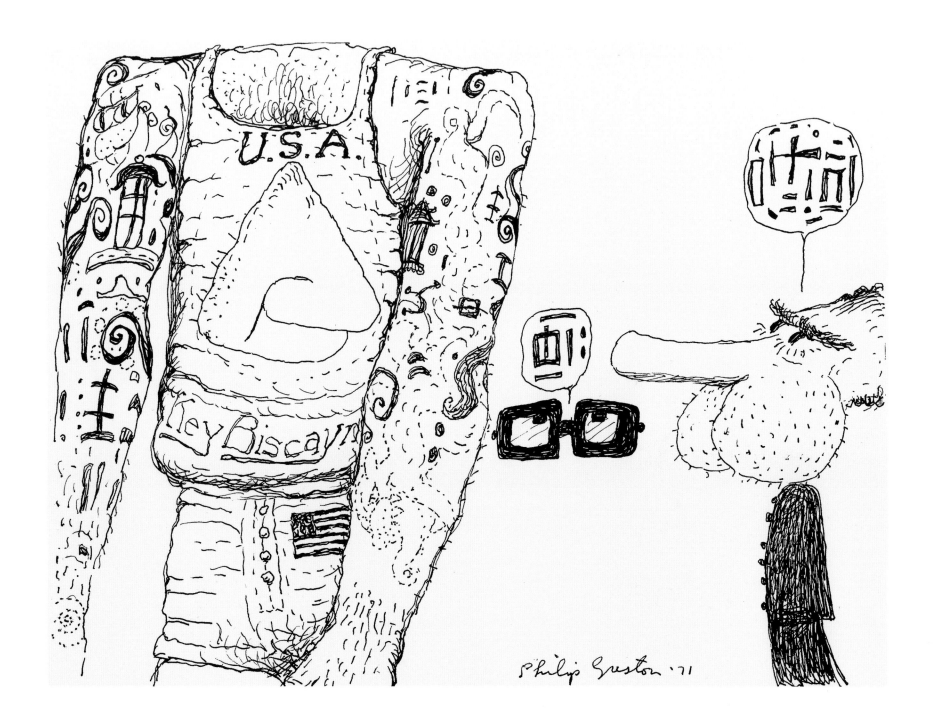

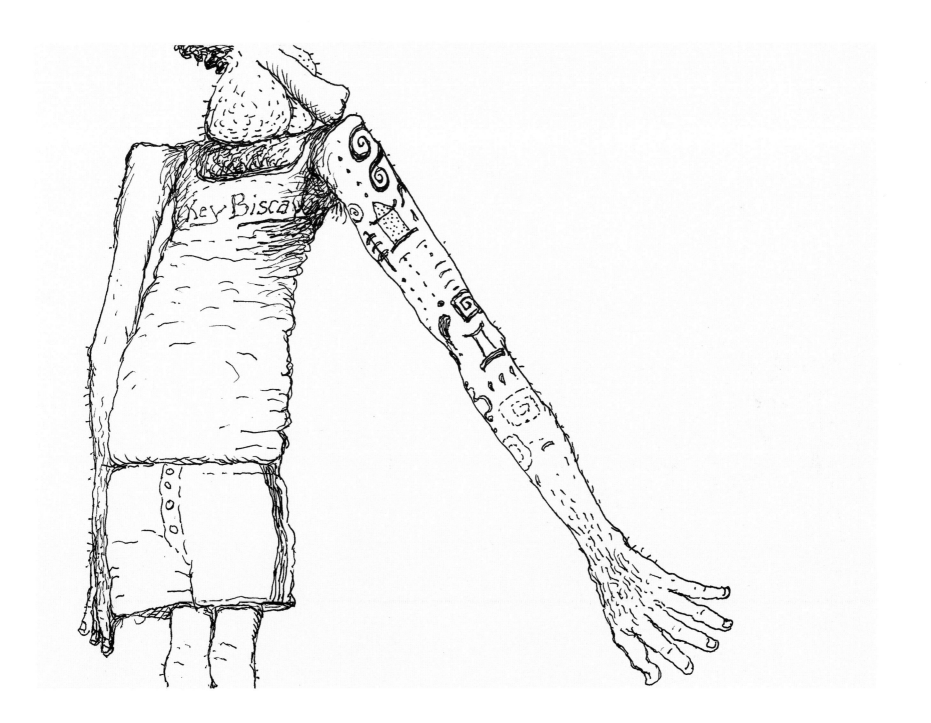

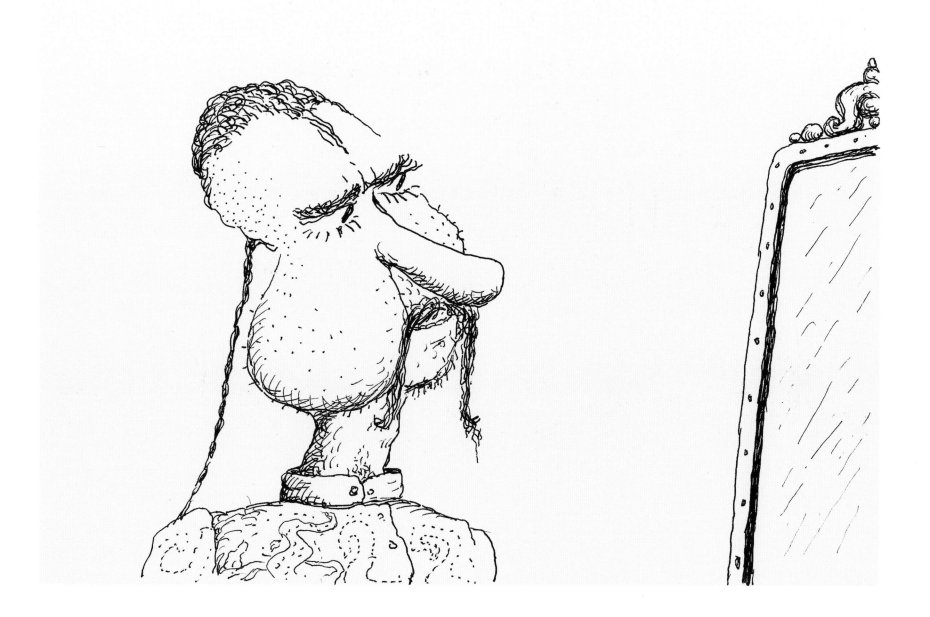

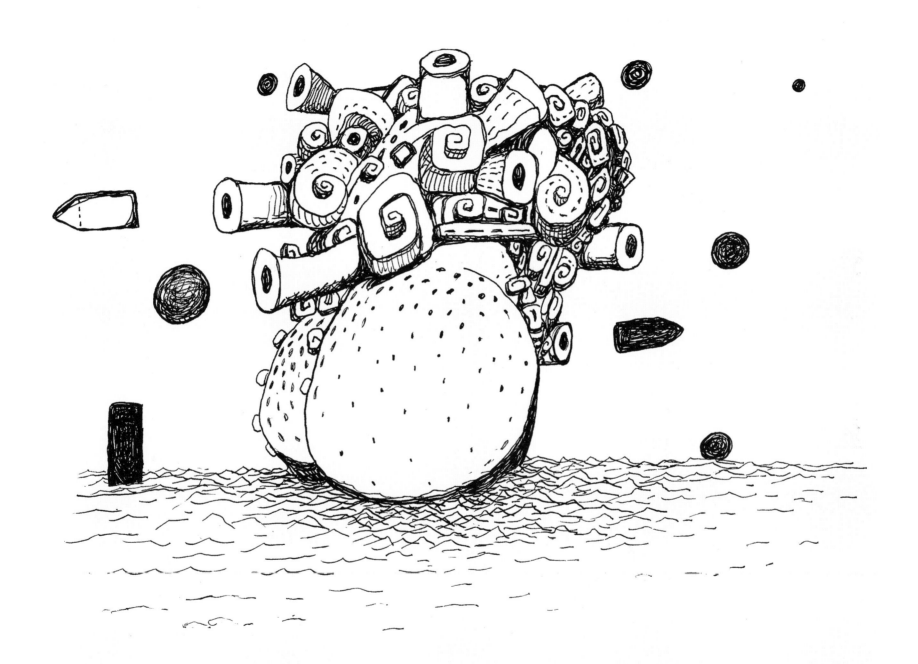

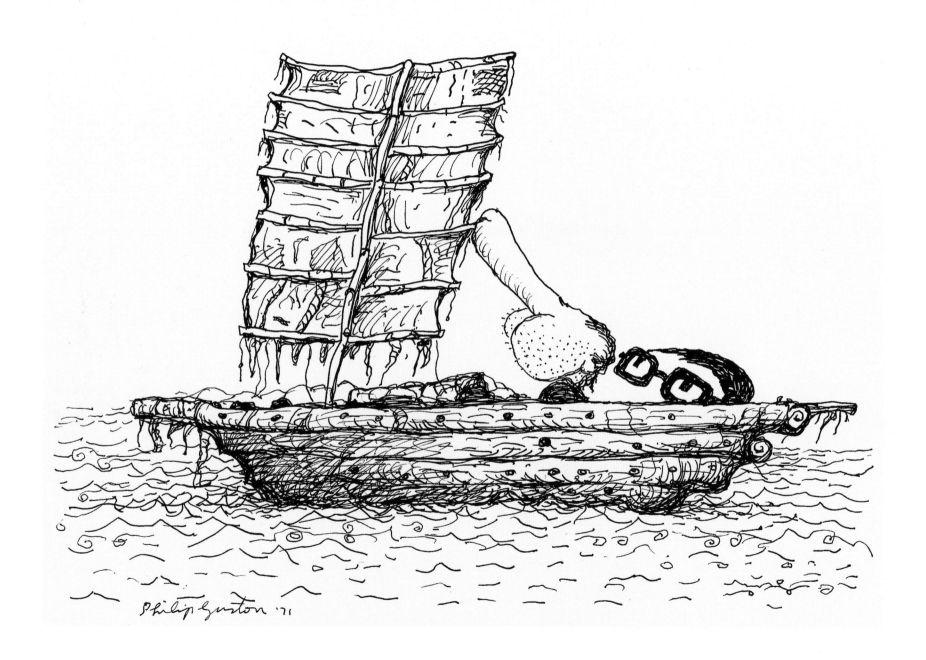

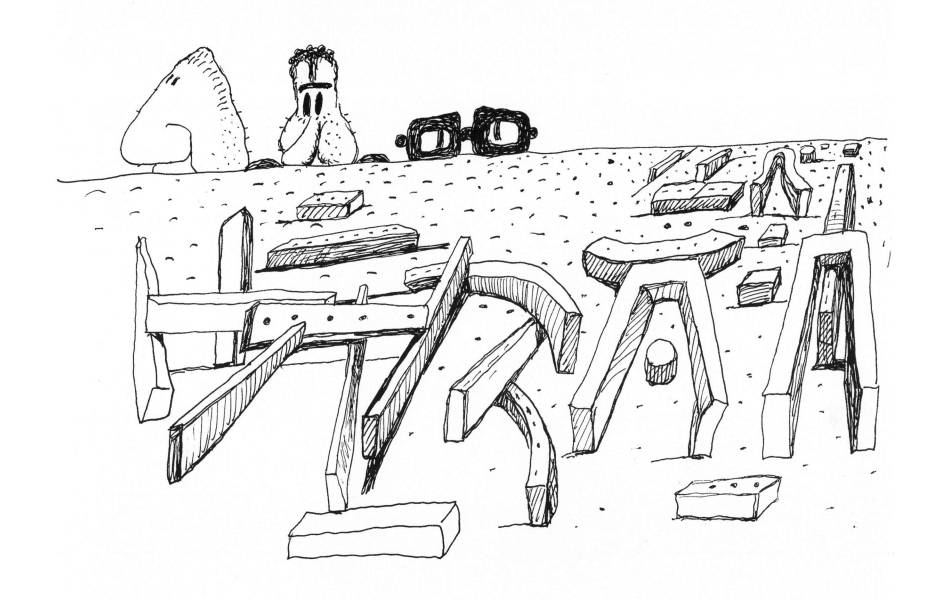

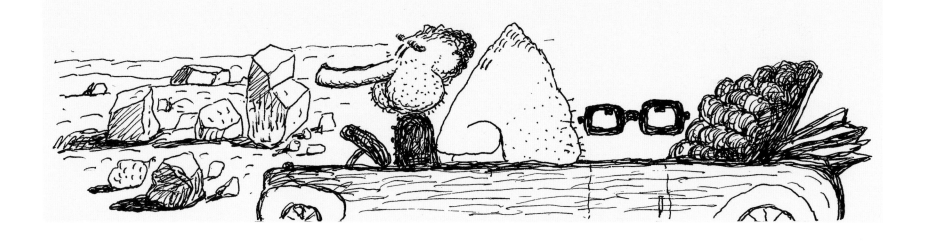

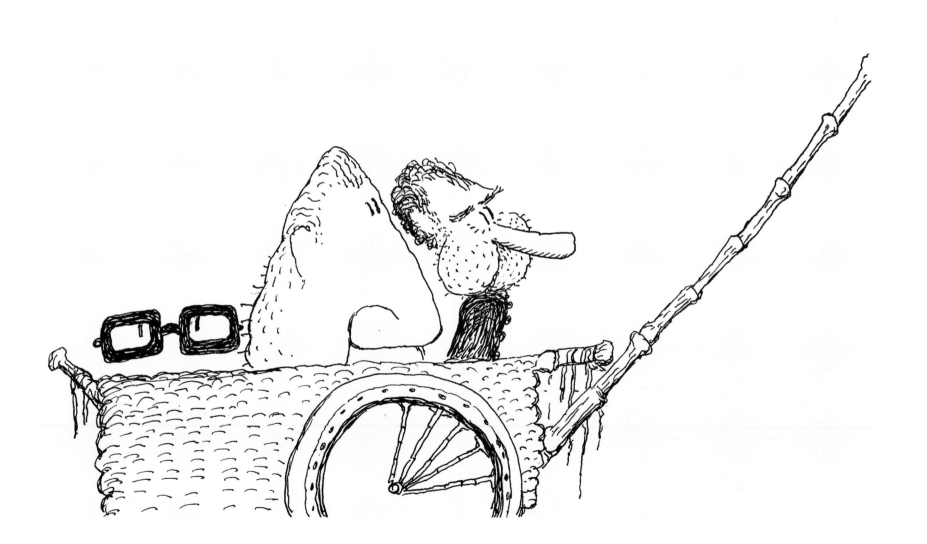

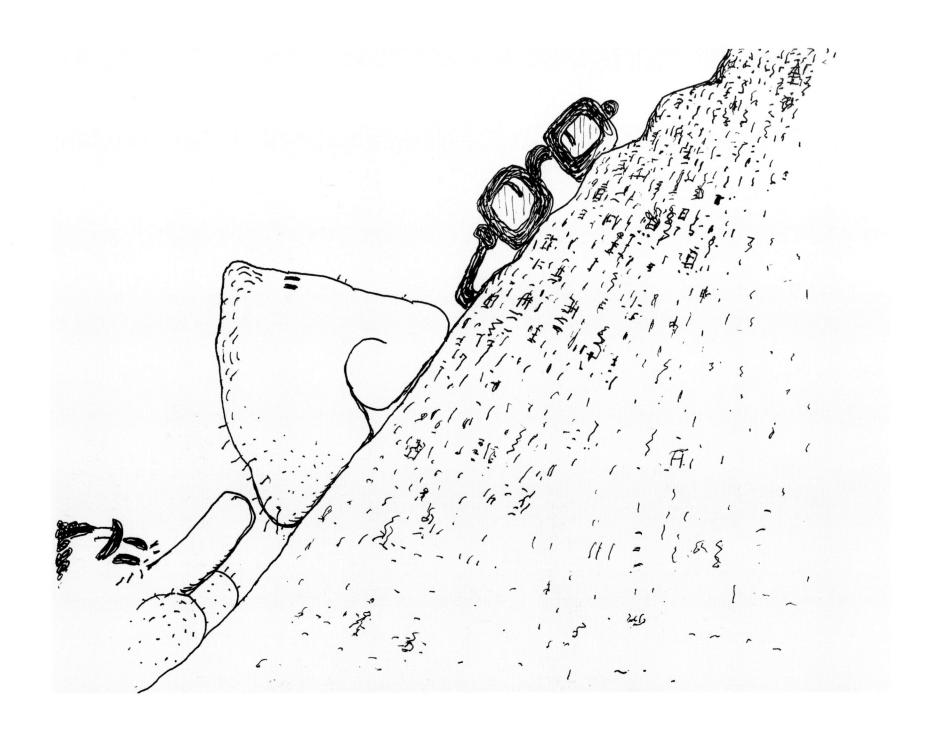

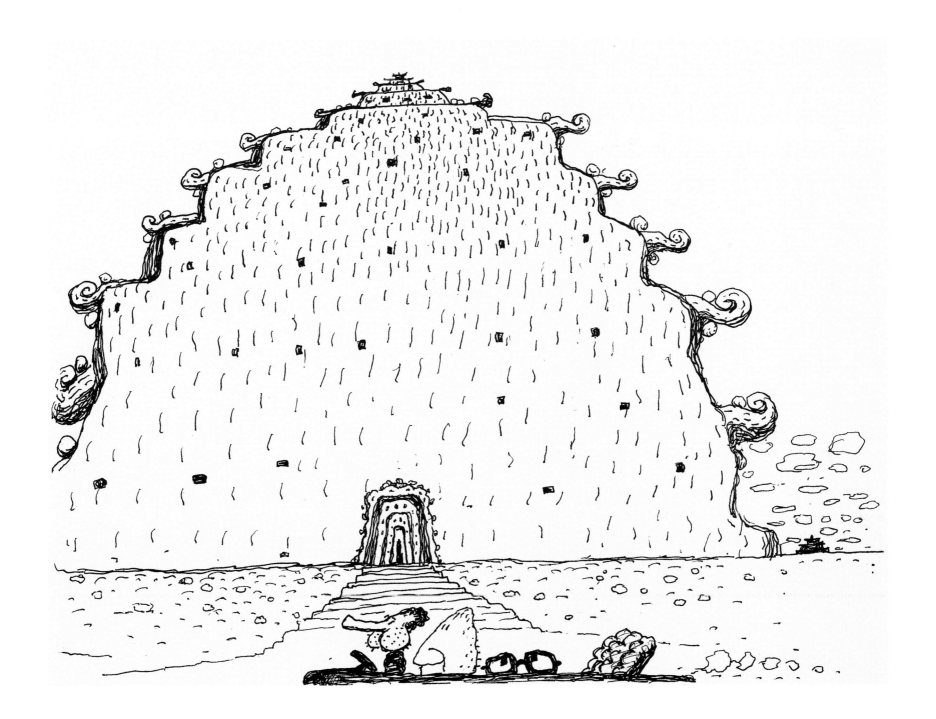

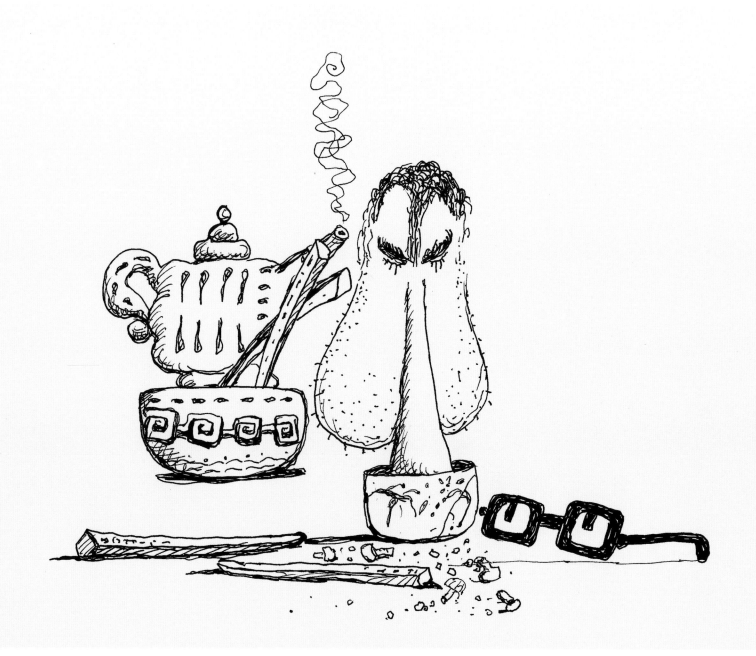

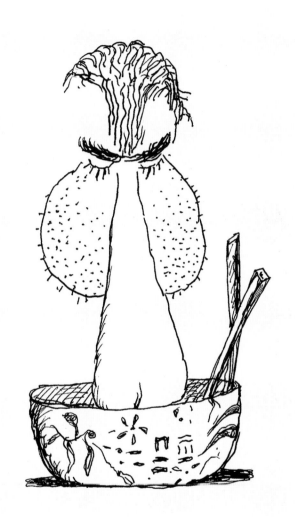

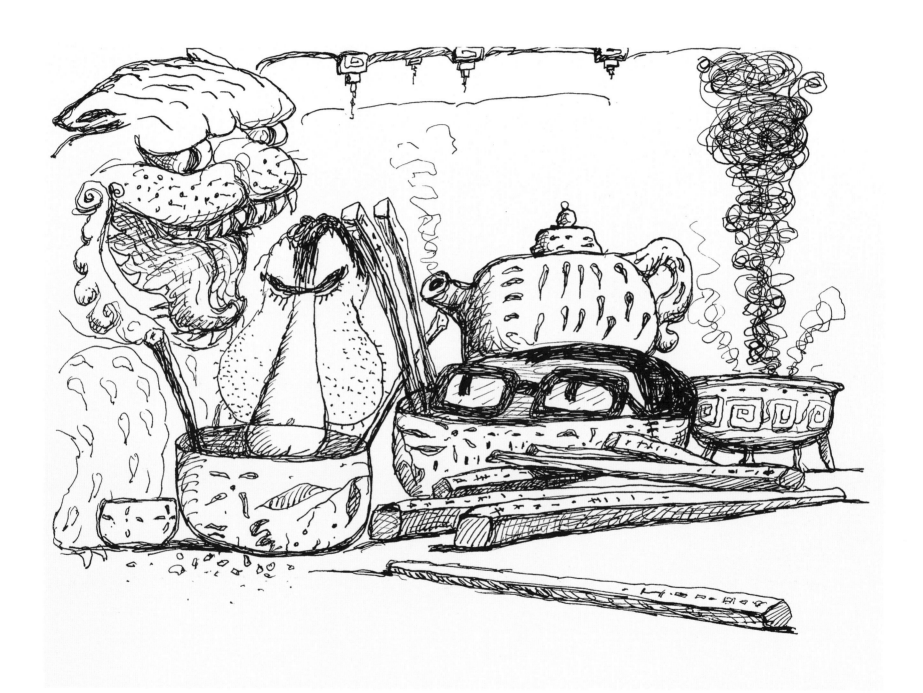

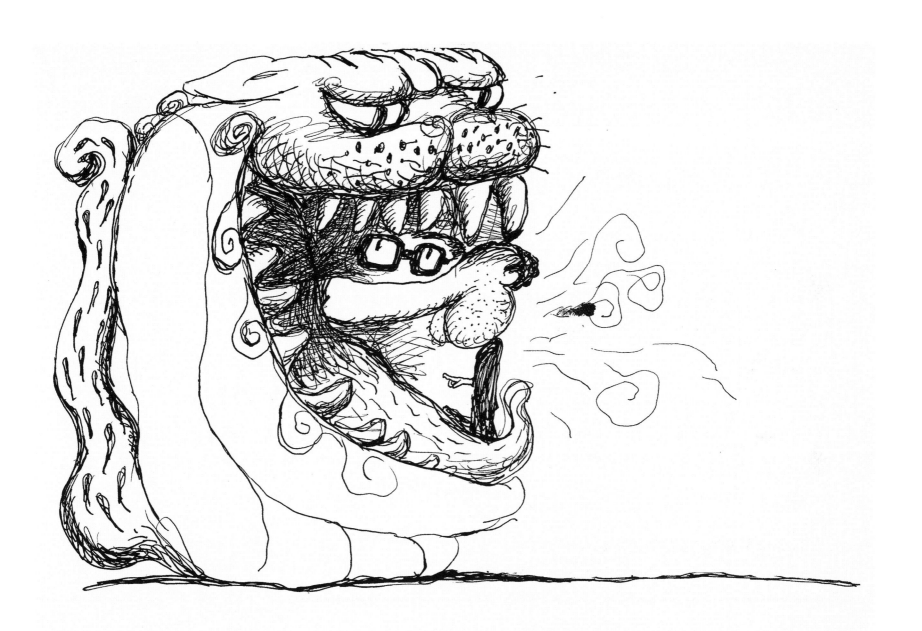

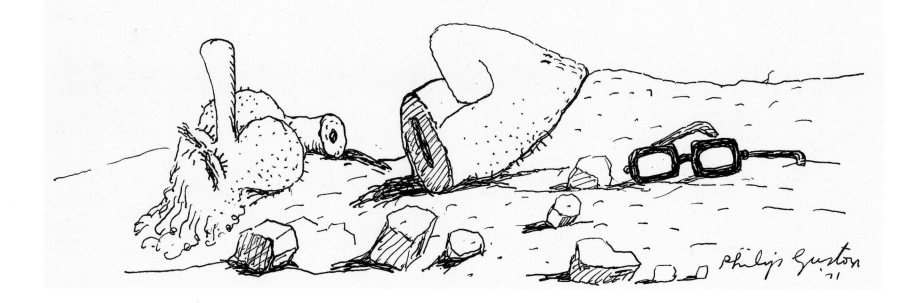

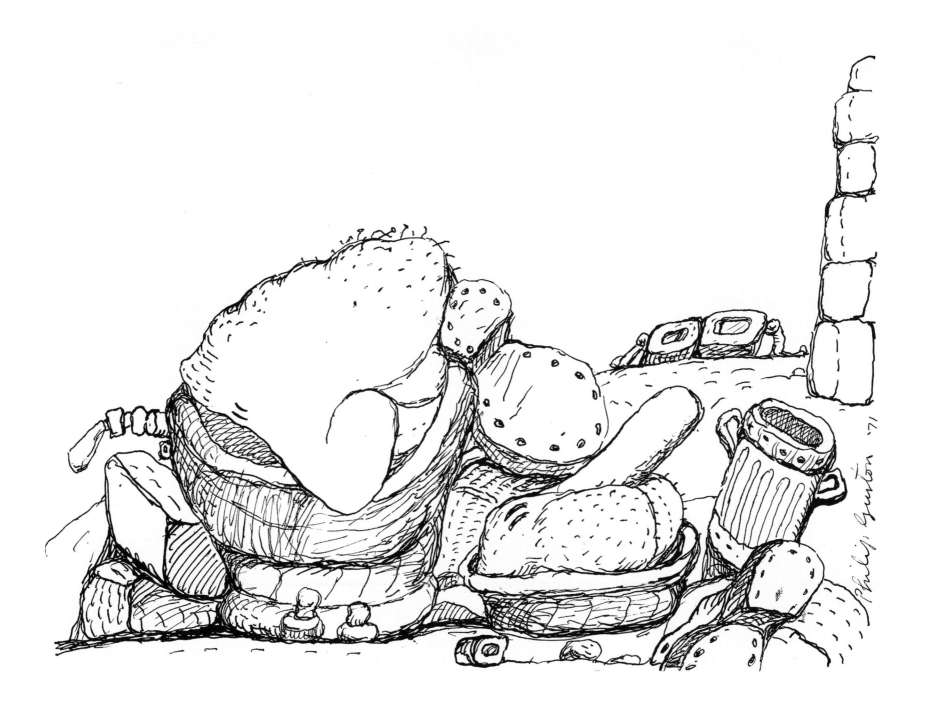

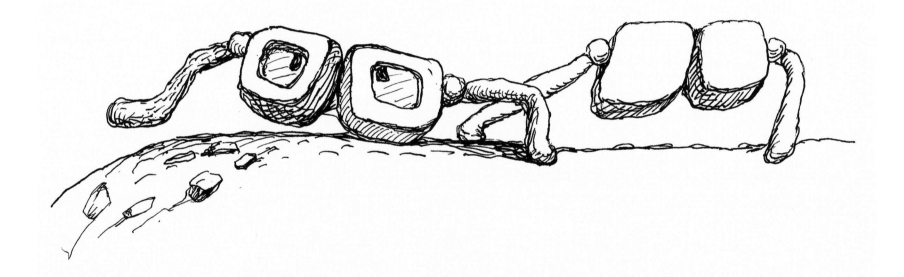

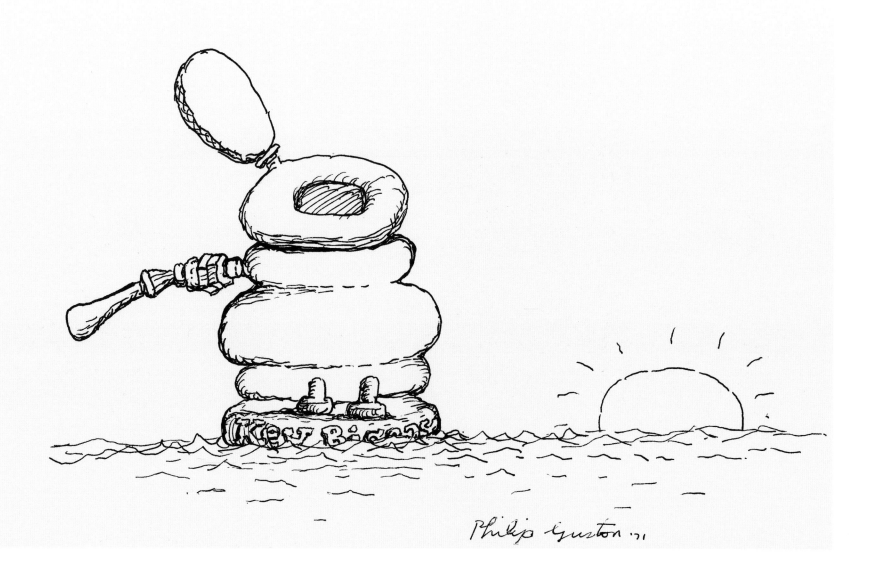

Philip Guston '71

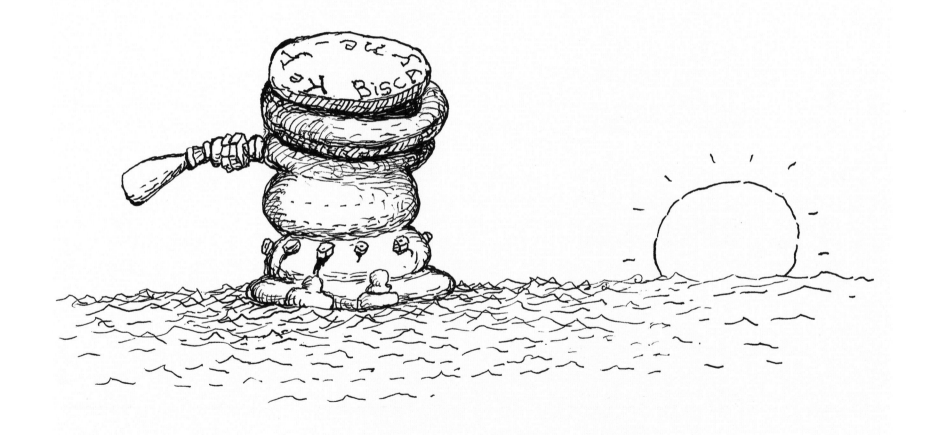

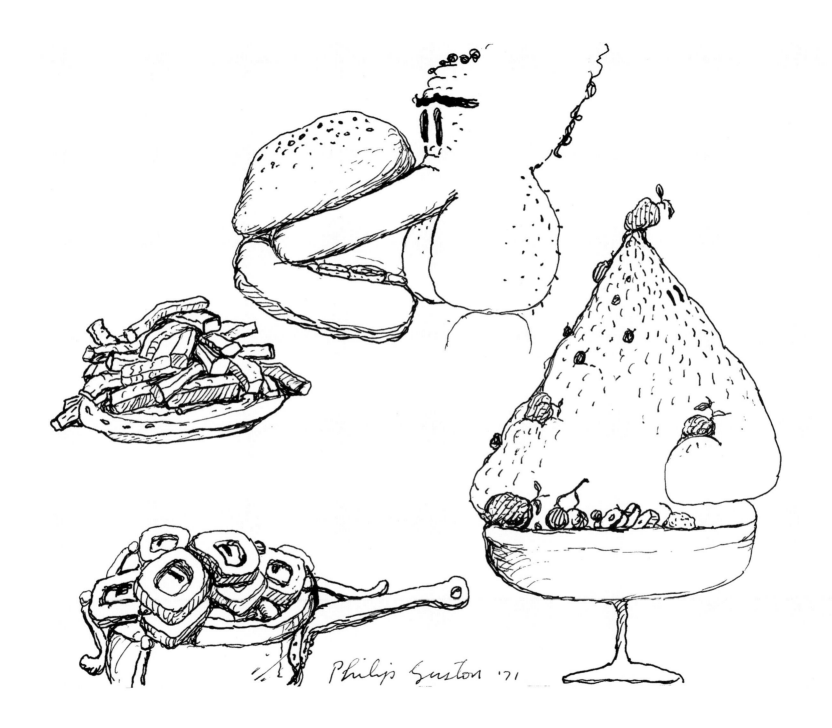

Philip Guston '71

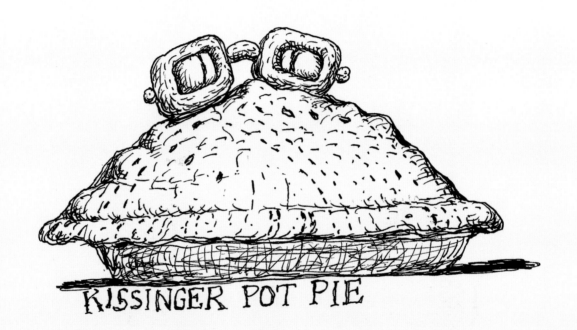

KISSINGER POT PIE

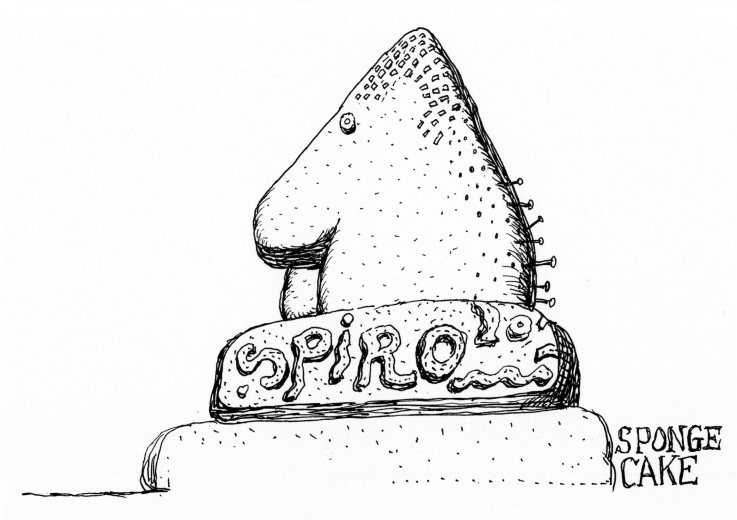

SPONGE
CAKE

philip g. '71

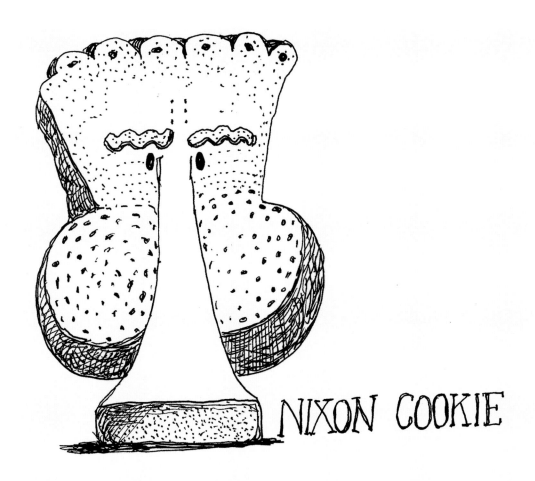

NIXON COOKIE

Part Two: A Fable of Politics and Modernist Art

"WHERE THE HELL DO THEY DIG UP ALL OF THIS?"

Roth has referred to *Poor Richard* as "pure play because it was detached from his ambition,"[34] a description which implies that this opus of caricatures represented an amusing diversion from other projects underway in his studio. The question of Guston's "ambition," especially as it pertains to *Poor Richard*, though, is not quite so clear-cut. That the drawings are layered with specific historic references and were made in one uninterrupted, consuming sweep suggests that Guston was engaged in more than just fun. While admittedly a jaunt from his setbacks in the art world, these images were initially intended by Guston to have a public life, to be seen and absorbed by an audience. In fact, the plan at the outset was to print them as a book in their full narrative sequence. He assembled these images carefully, assuring the right composi-

tional pairings and chronology would be read and observed, by placing them in a black binder, or mock-up, to present to various editors. But when Roth offered to engineer introductions to publishers on Guston's behalf, he became, as he noted, "ambivalent."[35]

Guston continued to entertain the publishing plan for a number of years, however. In one press notice in *Newsweek* for Roth's Watergate edition of *Our Gang* in 1974, mention is also made of the impending release of *Poor Richard*.[36] But Guston's doubts interceded once again and the book remained sequestered in his studio. When his old friend Harold Rosenberg's essay on Nixon and Watergate titled "Thugs Adrift" appeared in *Partisan Review*[37] in 1974, he wrote in appreciation, "I've just read your Watergate piece in P.R. and enjoyed it very much—beautifully reasoned and written and of course hilarious in a sober way (the sheer insanity) that delights me—I wish that

one of my NIXXON drawings had been used in it."[38] His periodic temptations to release *Poor Richard* always receded. Later, in 1975, when William Corbett, a new friend and poet from Boston, made similar overtures to publishers for Guston, he retreated again and the drawings remained unpublished.[39] While many writers besides Roth and Rosenberg had taken Nixon to task during this period, including Norman Mailer, Gore Vidal, and the filmmaker Emile de Antonio,[40] to name just a few outside of the scores of liberal journalists writing about Nixon on a daily basis, he feared the exposure *Poor Richard* might create, not wanting, as Corbett remembers, "to be taken as another Nixon hater."[41]

In 1971, the year in which *Poor Richard* was made, Guston's ambition, that is, the aesthetic aspirations which drove his work, remained in a state of redefinition, clouded by feelings of hurt from the critical reaction to the 1970 exhibition of his new paintings at the Marlborough Gallery. In a letter written in the spring of 1971 to Dore Ashton (who was then at work on a biography of the artist), he wrote: "You didn't hear from me . . . because I didn't have anything to say. I mean I became so depressed—deflated and low over the reception, misunderstanding of the show . . . I am back to 1950 again except that it is worse—because of the extreme codification of beliefs and the institutionalization of everything."[42] And in the years that Roth knew Guston in Woodstock, he had observed that "he couldn't leave the cave in which he hibernated because his nerves were too subtle for the travail outside. He was too wounded."[43]

To Guston "the extreme codification of beliefs" denoted the thinking of specific critics and artists. Outside of the lingering, still entrenched influence of critic Clement Greenberg (who never reviewed Guston's work—even in the 1950s at the height of Greenberg's preoccupation with abstract art),[44] and the "institutionalization" of formalist ideas in the academy and at the museum, Guston was particularly undone by Hilton Kramer, then a staff art critic for the *New York Times*. In his letters to Roth throughout the decade of the 1970s, long after *Poor Richard* was completed, Guston frequently dwelt on the oppression of criticism. In one particular letter in 1973, he revealed his trepidation about exhibiting his work again: "Well, here I go again—my first show out-

side of N.Y.C. Detroit is probably full of Hilton Kramer's. I'll bring you back the reviews in the Detroit Free Press(?)."[45]

Guston felt that part of his bond with Roth stemmed from a mutual contempt for the writers and pundits who reviewed their work. As he noted in one letter toward the end of the decade, "Our hates coincide—Oh yes, the 'fuckers' (as you say) more than ever."[46] After one particularly searing assessment of Roth's entire output by Irving Howe in *Commentary*,[47] Guston responded with a gift to Roth of a drawing which he titled "Critics and Artists," in which Howe, in a reverse take, appears defenseless, on his back and about to be avenged by an artist with a knife! Their banter on the privileged state of critical writing, its inflated power and pervasive mediocrity, was yet another aspect of the satiric dimension that animated their relationship. Like their mocking of Nixon, both figures seized on the sometimes ludicrous nature of criticism. For example, Guston wrote the following to Roth after an inane assessment in the *New York Times* of his 1974 exhibition at David McKee: "Did you catch last Sat review of my show—NOT BY KRAMER—this time by John Russell—not bad really but how did he know 'I was an urchin in his 60's who could lose a pound or two'—Where the hell do they dig up all of this? Besides couldn't he get his facts straight—it's 35 lbs. I need to lose—an 'urchin in his 60's?' What do you think?"[48] On another occasion, he expressed his desire to Roth "to *bite* off some Art Critics schnozola—and you know *who* I mean!"[49]

The allusion to the nose again, or schnozola, is telling. Nixon and Kramer become metaphorically merged as icons of perversity, depraved figures whose power is undeserved. Clearly, part of Guston's ambivalence in publishing *Poor Richard* was a fear of exposure, of revealing his vulnerability in the face of widespread criticism. What would the press make of these phallic images? Even when Nixon was disgraced and removed from the White House, when Nixon-bashing reached its zenith, the possibility of attack from Kramer and others posed too great a risk.

In addition, Guston was overcome with the profound realization that art had degenerated into what he referred to as "genre painting,"[50] a now debased, pale iteration of the tenets of modernism. He believed that "contemporary American Art is [not] much worth talking about. It's college art . . . To-

tally mannerist. In the last several decades modern art has been degraded into ornament . . . In an office building you're not going to see one of my pictures on the wall, next to the plant."[51] The continuing proliferation of formalist theory—at least through the instruction of painting in art schools—contributed much to the demise, Guston intimates, of modernism. Calcified and overly precious, abstract painting, he thought, was no longer driven by any deep aesthetic inquiry, let alone revelation of the artist's interior life. Its formulaic prescriptions seemed caught, at least to Guston, in an endless repetition of known inventions. In order for art to have any shot at revitalization and renewal, he believed, it had to be "critical."[52] While "direct political interpretation,"[53] as he put it, was not always what he had in mind, his questioning of the weight and authority of modernism, of its inability to remain current in the late twentieth century, was essential to his revised aesthetic outlook. And within the context of his late work, this critical pondering took the form of reintroducing previously repressed forms of art, such as caricature.

In the frequently hermetic language of modernist criticism, with its emphasis on pure form and visual pleasure, Guston found much to scorn after 1968. Once he abrogated his own involvement with abstraction, he came to tire of the elusive yet entitled discourse that buttressed its practice. Describing a teasing exchange in 1970 with Thomas Hess, editor of *Artnews*, involving his so-called late work, Guston reveals how his impatience with the rarefied nature of critical thinking took on yet another comic, but acerbic, twist: "Before they were shown at Marlborough, Tom Hess . . . heard something was up, so we went over to the warehouse to see them. He looked at this painting . . . one with a piece of lumber with nails sticking out, and he said, 'What's that, a typewriter?' I said, 'For Christ's sakes, Tom, if this were 11 feet of one color, with one band running down on the end, you wouldn't ask me what it was.' I said, 'Don't you know a 2 by 4 with red nails?'"[54]

But the conversation that grew out of his friendship with Roth represented something quite different. "I truly enjoy his reactions," Guston once wrote, "—very '*straight*'—*tough* and not from the 'art side.' His Humor, satiric side really delights me and he brings out in me, my own bent for the *pathetic and comic*."[55] Moreover, in Roth's work he located a "balance between rancor and

self-knowledge"[56] that he deemed to be crucial to any artistic project. The question of Guston's ambition for *Poor Richard* and his late work in general remains, then, caught in this spurning of modernism, and of the power of the discourse which supported its forms. Like the "new Nixon" and his political victory in 1968, Guston, ironically, had embarked on a new phase of his artistic life. That his so-called late work was intensely autobiographical, and filled with self-doubt, explains in part his "ambivalence" towards the public consumption of *Poor Richard*, a body of work which is among his most personal.

"I DON'T KNOW, MAYBE I AM FASCINATED BY EVIL"

As early as 1965, Guston began to question the whole project of painting, stating, "I am beginning to feel that there shouldn't be any painting . . . There are enough paintings in the world. Life and art have a mutual contempt and necessity for each other."[57] After more than two years of wrestling with this insight, wondering whether painting could hold on to its primacy and status, the curious mix of figures that took over his work around 1968 seemed the only way out of this perceived impasse. Moreover, Guston felt that he was left without a choice, unable to stifle or control the imagery. When the last vestiges of the emotive marks retreated from his canvases, he was, as he has said, "left only with a sense of my perversity. Yet I must trust this perversity."[58] The transgressive or perverse character of Guston's late work, its obvious slap at modernism's purity, is entangled in what he also came to refer to as his "new dream of violence,"[59] a Kafkaesque nightmare that drew on aspects of his own life experience.

That the figures of the KKK, books, clocks, and shoes surfaced around 1968 was triggered, in part, by reaction to international events. As Guston was cogitating on the viability of abstract painting, widespread social dissent was overwhelming North America and Europe. He remembered that "when the middle 1960s came along I was feeling very schizophrenic. The war, what was happening to America, the brutality of the world. What kind of man am I, sitting at home reading magazines, going into frustrated fury about everything—and then going into my studio *to adjust a red to a blue?*"[60] Guston's sense

of alienation from modernist art became too great; and the idea that painting had to be connected to a larger political and social nexus in order to distill value became paramount. In his emotional responses to the war in Vietnam and civil unrest in the streets and on campuses, he found more vital material for his painting, noting, "I didn't march against the last war, but I did decline to go to LBJ's White House. Politics. I don't see how one can escape it."[61]

The correspondences between the violence of the world and his own psyche became almost seamless in his work from 1968 onward. "I have *never* been so close to what I've painted," Guston claimed, "not pictures—but a 'substitute' world which comes *from* the world."[62] But on the content of his imagery, he preferred any reading to remain generalized and summary. It was as if its brutality was even too much for him to acknowledge. Guston's ambivalence toward the way in which his new work would be canalized, especially by critics, surfaced in numerous contradictory statements. "Social subjects?" he said in one refutation, "Oh, Christ! I guess so—but when hasn't it been so. But of course that's not the meaning of them . . . Naturally it's ridiculous to claim they represent the troubles and terror we live with—as if it's unique—who doesn't feel all of this no matter what you do . . . It is just that the subject that I paint makes me want to paint—that is, to *see* it—and the range I feel in myself in the making of it . . ."[63]

However, the self-references in Guston's painting and drawing from the late 1960s onwards and their intersections with a wider culture are too palpable, and his occasional, protective refutations shouldn't be taken at face value. The imagery of the Klan, in particular, is among his most charged and symbolic. He referred to these figures as "self-portraits. I perceive myself as being behind a hood."[64] Guston had been drawn to the image before: it was one that had populated his work from the outset of his career around 1930 and which he had recirculated for almost seventeen years before his elimination of the figure in 1947.[65] As he has noted, "The KKK has haunted me since I was a boy in L.A. In those years they were there mostly to break strikes, and I drew and painted pictures of conspiracies and floggings, cruelty and evil."[66] That the KKK resurfaced in his drawing after a twenty-year hiatus, as his lyrical abstractions began to wane, is clearly linked to his despondency over both

world events and the meaningless beauty of abstract art. While distanced and masked by the hood or getup of the Klan, Guston knew that these malevolent figures were extensions of his own psychology. "I don't know," he said, "maybe I'm fascinated by evil."[67]

He endowed the image with multiple significations, explaining that "in the paintings of 1968–70, I also made the hoods into painters. There were pictures where the hoods became artists . . . I also had them discussing art, becoming art critics; I had one looking at an abstract painting."[68] The fusing of the artist and critic as Klan became yet another resonant metaphor for the collapse and decay of modernism. By producing this sort of self-portrait, Guston readily admits to his having colluded with the degeneracy of contemporary painting. Hence the great ambivalence that surrounded the release of all of these images, including *Poor Richard*. He began to identify with a longstanding favorite writer, Isaac Babel, and his short stories about Cossack outlaws who were absorbed by the Red Army during the Stalinist era: "Like Babel with his Cossacks, I feel as if I have been living with the Klan. Riding around empty streets, sitting in their rooms smoking, looking at light bulbs . . . windows . . ."[69]

The Klan also shows up in *Poor Richard,* as we have seen, with Nixon, Agnew, and Mitchell clad occasionally in hooded outfits. Guston, having depicted himself similarly in his various "self-portraits," reveals insight into, if not therefore kinship with, their delusions and hypocrisy. Nixon as Guston's alter ego in *Poor Richard*? Almost, but not quite. In the loneliness of his Woodstock studio and cabin, Guston underwent a deep self-analysis around 1968, finding bits of his persona in myriad literary sources (such as Babel and Kafka) as well as in a political figure like Nixon. While certain symmetries and coincidences unify the lives of both men—Nixon and Guston were both born in 1913 and spent their childhoods in Southern California in economic hardship, and, as William Corbett has observed, "both knew great acclaim and rejection"[70]—Guston, unlike the president, possessed, as he has said of himself, "a capacity for self-criticism."[71] The savagery of the caricatures in *Poor Richard* could only have been realized through a merciless self-questioning, an admission by Guston of his own collaboration in a bankrupt artistic project. As such, the images double both as political and cultural satire, layered with literal references to the folly

and duplicity of a president, as well as, less pointedly, to the failure of an aesthetic movement in which Guston once had a primary investment.

Guston had always been troubled by the absence of narrative content in abstract art, of a figure or representation for the viewer to hold on to. As he had averred at the height of the success of the New York School, "I do not see why the loss of faith in the known image and symbol in our time should be celebrated as a freedom. It is a loss from which we suffer, and this pathos motivates modern painting and poetry at heart."[72] Where pathos had once been his subject, the comic and pathetic, as Guston noted in the context of his relationship with Roth, became a dominant interest around 1968. "Pictures should tell stories,"[73] he said, and in the evil and injustices of life, he found ample fuel upon which to base his new work, as well as to reveal aspects of his perturbed emotional state.

"NO I DON'T PLAN THE CRUDENESS"

Guston's "new dream of violence" induced a flood of early memories around 1968 that extended well beyond the Klan. Besieged by an overall feeling of the inequity of life, its horrors, brutality and oppressions, he revisited specific events that were subsequently woven into the lexicon of imagery in his new work. "Our whole lives (since I can remember) are made up of the most extreme cruelties of Holocausts," he wrote to Bill Berkson, a poet and art critic who remained close to Guston throughout this painful transition. "We are the witness of this hell. When I think of the victims, it is unbearable. To paint, to write, to teach, in the most dedicated sincere way, is the most intimate affirmation of creative life we possess in these despairing years."[74] The seemingly incongruous juxtaposition of books, light bulbs, clocks, bottles and shoes, on the one hand, with images of the Klan, or self-portraits, on the other, is actually representative of a range of specific childhood incidents and interests. If images of the KKK had been inspired by having witnessed that group wielding their pernicious power as goons and strikebreakers in Los Angeles, his work was also embedded with allusions to boyhood sanctuaries and passions.

The suspended light bulb, for instance, which appears in his painting and drawing well into the mid-1970s, and in *Poor Richard*, was a reference to the source of light in a closet in his family's home where he would seek refuge to read and to paint. Moreover, the book, another ubiquitous image that figures in his late work, affirms not only a life of reading, but the significance of his friendships with writers, such as Roth, during this period. "I read, so I painted books, lots of books. I must have painted almost a hundred books. Its such a simple image, you know," he mentioned in a conversation with Rosenberg.[75] But these images, like the clocks (an embodiment of the awareness and pressure of time), the bottles (his acknowledged need for alcohol), shoes and boots (symbols of the storm troopers, or the authoritarian figures, including the Klan, who enacted the injustices he experienced and read about as a youth),[76] paint brushes (an allusion to his craft), and the overall "junk,"[77] or stuff as Guston described these sometimes piled images (his father worked as a junkman until his suicide in 1923, another haunting, indelible memory), were all shaded by his anxieties and frequent depressions. While Guston yearned, as he said, "to become complete again, as I was when I was a kid," this fragmented array of objects revealed a partial, selective recounting of his past. His ferreting of personal history became filtered by topical political events, by an overall sense of injustice and empathy for the social turbulence rocking America. And these connections, however indirect, constitute an important aspect of the meaning of his late work.

All of Guston's images, moreover, whether of the Klan, Nixon, books or shoes, were rendered with an immediacy that dispenses with the refinement or grace that had once defined his emotive abstractions. His late paintings and drawings are completely disaffected of beauty. In the language of caricature, Guston found the right match for or equivalent to his emotional state. By the mid 1970s, when these cartoon-type figures had thoroughly settled into his work—but their brashness was still capable of inducing disdain[78]—he noted, "I don't think about beauty, anyway I don't know what the word is. But, no I don't plan the crudeness."[79] The unleashing of imagery around 1968 was, again, unstoppable and eventually something Guston had little desire to restrain. It was part of his recovery of his past and self-excavation, of an earlier moment in his painting when the figure, however carefully worked, was a

primary expressive vehicle. "Comments about style sound strange to me," he said, "as if you had a choice in the matter . . . it's all circular."[80]

Like Gregor in Kafka's *Metamorphosis*, a story Guston reread throughout his life, the transformation was essentially basic, a complete aesthetic overhaul to regain a lost subject matter or content. The process involved retracing his steps, the inverse of most artistic developments. He felt that "there are times in one's life that you begin, all over again, from the beginning—a true turning over—a heave in my case. As if I had metamorphosed again, perhaps from something in flight into some kind of grub."[81] This reversal involved recapturing not only the image of the Klan with all its malevolent connotations but also the irony and satire associated with the genres of caricature and the comic strip—all of which involved a reclamation of childhood.

From the beginning (to play on and underscore the notion of origins and fresh starts that runs through this late phase of his work), Guston was drawn to and intrigued by the art of cartooning. In fact, his first introduction to art came by way of a correspondence course offered by the Cleveland School of Cartooning which his mother encouraged him to take at the age of thirteen after he had expressed an interest in drawing. While he tired of the assignments quickly, finding them too monotonous and unchallenging—the course required adhering to the conventions of commercial illustration—he remembers that as a boy, "I used to dream of having my own strip one day."[82] Whatever the limitations of the lessons, he continued to produce cartoons. In 1928, he entered and won a contest sponsored by the *Los Angeles Times* for new cartoons by teenagers.[83] He also absorbed the comic strips of George Herriman, that is, his zany *Krazy Kat*, which was syndicated in numerous Hearst publications; Bud Fisher's *Mutt and Jeff*; and the animated cartoons of Disney's *Mickey Mouse*. In these forms of so-called popular expression, Guston located a radical, innovative style which he knew expanded on and added as much to the language of contemporary art as experimentations underway in pure painting.

While *Krazy Kat, Mutt and Jeff*, and *Mickey Mouse* were politically neutral, cut off from satirizing topical events and government and corporate leaders, their novel, ingenious graphic traits, along with their obvious comic appeal, rep-

resented to Guston a bold amalgamation. In the case of *Krazy Kat*, especially, Guston was taken by Herriman's rendering of the metaphysical landscape of Coconino County, Arizona, in which the romantic triangle of Krazy (a cat), Ignatz (a mouse), and Officer Pupp (a dog), unfolds. The correspondences between this abstracted topography—its elegant and translucent paring of essential form—and subsequent artistic developments in 1930s, particularly with the surrealism of Joan Miró, were striking.[84] These sources reinforced that artistic invention was not always a highbrow affair, that the comic and ludicrous when wrought with original form could be just as potent as avant-garde painting.

In the issues of *Americana*, a publication which came out of Los Angeles from 1932 to 1933, and which was edited by Alexander King with George Grosz and Gilbert Seldes as associate editors, Guston came across the type of acerbic caricatures which would eventually inform *Poor Richard*. While his late paintings and drawings appropriate and restate a number of visual tropes from *Krazy Kat, Mutt and Jeff*, and *Mickey Mouse*—the disembodied, bony legs with their bulging shoes, for example, derive from Disney; the enlarged boot or shoe sole from Fisher[85]—the caricatures of political figures such as Hitler, Stalin, Mussolini, Gandhi, Herbert Hoover, and Franklin Delano Roosevelt featured in *Americana* were unrelenting and scathing in their treatment, a feature associated only in Guston's work with his rendering of *Poor Richard*.

In the issues of this short-lived publication, he learned that the cartoon could be didactic and an effective means to channel a sense of political outrage. The always condemning, frequently sexualized take in *Americana* on leaders like Hitler—who in one issue is represented in a cartoon by Otto Kleist as emerging from the rear end of a German officer, accompanied by the caption "The Spokesman for Heinie,"[86] in another, by Hirshfeld as an effete dancer in a chorus line made up of Nazi soldiers, with the title "Oh, Adolf"[87]—had a cumulative, but delayed, impact on the artist. *Poor Richard* emerges almost forty years after Guston's reading of *Americana*, but like the images which overwhelmed him from his past around 1968, these caustic and farcical portrayals of world leaders molded part of his latter-day handling of Nixon, Agnew, Kissinger, and Mitchell.

While the astringent and cutting characterizations in *Poor Richard* represent a singular event in Guston's output, his interest in the comic strips, cartoons, and caricatures[88] that he had followed as a youth, and which he assimilated through his introduction to art, soon became repressed, yielding to the more heady practice of painting. He held on to the moral dimensions of the cartoon, connecting his work with his social conscience from the 1930s until the mid-1940s, but when the internal pressures to stretch the elusive language of abstraction became a critical issue around 1947, whatever political content had lingered in his work, at least through his lengthy use of the Klan as a symbol, dissipated. The temptation to investigate caricature as a genre remained, however, and was privately enacted shortly after this juncture. For, from 1950 onwards, he produced a series of caricatures of friends, such as Rosenberg, Willem de Kooning, Franz Kline, John Cage, Robert Motherwell, Ad Reinhardt, Mark Rothko, Barnett Newman, Saul Steinberg, and Stanley Kunitz, among many others, eventually including Roth in this pantheon.[89]

Whatever the elegance and wistful beauty of his abstract works, these "playful" ventures revealed a sustained interest in figuration that becomes ironically re-ascendant in Guston's so-called late period. As astute observations of human physiognomy and character, his pencil drawings or caricatures of friends rely upon distortion and exaggeration to distill the alternatively comic and poignant traits of each person. Rosenberg, for example, is a thick mass of mustache and eyebrows on a large frame (his size and facial hair being salient features); whereas Roth is an elongated nose with eyeglasses and a crown of curly hair (which perhaps extends and plays on the primary motif of the schnoz in *Poor Richard*).

Rosenberg, ever the champion of Guston, when assessing the comeback of the figure in his work around 1968, wrote, "The most vital new element . . . comes from Guston himself—from the extraordinary caricatures he has been producing for years but until now has excluded from his paintings."[90] This visual link or hinge to his youthful forays into cartooning determined in part, as Rosenberg realized, the formal attributes or style of his late work. Whatever their underground status (and however downplayed by most curators and writers as a marginal feature of his work),[91] his caricatures of friends kept alive a fundamental aspect of his early work. As Guston himself contended, the crudeness was unintentional: it was there all along.

I AM A STUDENT OF ALL ART[92]

But unlike the single portraits or caricatures of Rosenberg, Roth, and others, which stand on their own without a unifying narrative or cohesive theme, *Poor Richard* basically abides by the format of a comic strip. As a sequence of images, it is endowed with a temporal dimension. Although stripped of a dialogue, captions, or accompanying titles, Nixon and his cronies are animated by the chronological structure that builds to his trip to Asia. But *Poor Richard* also carries an intangible sub-text (outside of the prescribed history), or even a capricious audio track, which consists of our own humorous reactions to and offhanded commentaries on Nixon's foibles and fate. Like Guston's and Roth's ongoing mimicking of the president, these images come with a metaphoric voice-over. As such, they touch on another of Guston's early fascinations—the cinema, in which he worked as an extra in his youth, and which was historically foreshadowed by the comic strip and its framing devices. Guston, who read film theory extensively[93] and knew the director John Huston and screen writers such as William Saroyan and Nathanael West,[94] the author of *The Day of the Locust* (which is filled with references to Goya, Daumier, and Picasso, as well as to scene painting), found further crossovers and analogies between film and painting in the discussions which grew of these friendships and reading. Long after he left Los Angeles, he remained an inveterate filmgoer, devouring, as Ashton recounts in her biography of the artist, "everything from third-rate Westerns to continental thrillers."[95] He also remained interested in the films of V. I. Pudovkin, the Russian director, while absorbing wholesale the work of Federico Fellini, a figure who loomed large in his Olympus of artists (and to whom he would dedicate a painting, in 1958, titled *To Fellini*).[96]

Robert Phelps, a writer who became a close friend in Woodstock in 1947, just as Guston was caught in the first of his aesthetic transitions, remembers that in addition to the many genres of writing and authors they discussed, along with his diverse group artistic preferences, such as Piero della

Francesca, Goya and Watteau, the art of the American comic strip ranked at the top of his visual interests.[97] Besides the ongoing recognition of Mickey Mouse made through the skinny legs and bulging shoes which appear throughout his late painting, the cartoon character is also extolled—inscribed within a heart no less—in a self-portrait or image of the artist's brain that Guston gave to his dealers, David and Renee McKee, in 1976. A poster made in collaboration with Stanley Kunitz for a (failed) series of poetry readings at the Smithsonian Institution in 1976,[98] the reproduction for the McKees was filled by Guston with drawings and the names of his allegiances, dislikes, and anxieties.

Mickey Mouse and Fellini are permanently etched in his memory, for example, as are his wife Musa, Italy, pastrami from Delancey Street, and Windsor Newton paint, among other favorites. These are offset by annoyances such as Hilton Kramer (with a gun pointed at his name), Clement Greenberg (which is spelt backwards), who is pitted against his rival, Harold Rosenberg (Guston's steadfast advocate), as well as his worries, such as money and his ulcer, and his desire for an end to violence (a Klansman's head is painted in one compartment of Guston's brain with the caption "No More" placed above it). In this little inventory, this short-list of Guston's late life, of the places, people and objects that occupied some of his appreciation, frustration and thinking, it is revealing that Mickey Mouse and Fellini are the sole representatives (outside of the art critics) of visual culture. In the cartoon character and the movie director, in the reference to the Klan and to brutality, Guston's early interests and experiences are intertwined, yet again, and brought full circle. The filmic pacing and caricatures in *Poor Richard* are similar amalgamations of these early aesthetic preoccupations, and they structure and delineate a contemporary political reality.

Outside of these personal, internal quotations, however, *Poor Richard* updates and extends a long tradition of political caricature, incorporating a history that includes Goya's *Los Caprichos* (1799), a ridicule of among other things the grandiosity and bigotry of the Spanish clerics, and Picasso's *Dream and Lie of Franco* (1937), a satire of the grotesquery of the Spanish general, which like *Poor Richard* extrapolates its frames and sequencing from the comic strip and is devoid of titles. Within the chronological span and development of the caricature and the cartoon, which would become almost indistinct, certainly close entities, when applied to politics from the late eighteenth century onwards,[99] the examples of Goya's and Picasso's use of caricature stand out in reference to Guston, representing as they did among his most studied and revered artists. That Picasso drew on the language of caricature throughout his work, as both an inventive and a subversive device, corresponds to the hybrid origins of Guston's late work, and its use of the cartoon among other forms or cultural sources.

Guston also undoubtedly would have known of the use of social satire by artists such as William Hogarth, whose *A Harlot's Progress* (1730) allegorized a public scandal in London involving the rape of a servant by a noted military officer, imparting a distinctly moral tone to the genre. *A Harlot's Progress* was Hogarth's first suite of prints to dispense with a text, relying exclusively, like *Poor Richard*, on exaggeration for comic effect. Similarly, the political sketches by James Gillray of Napoleon and the Duke of Wellington, as well as Charles Philipon's and subsequently Honoré Daumier's satiric distortions of the anatomy of the leaders of the French Republic in the early half of the nineteenth century, many of which were grossly sexualized, exist in the background of *Poor Richard*, serving as prototypes, examples, and lineage. But like his introduction to the parodying of heads of state, politicians, corporate fat cats and moguls in *Americana* by King, Grosz, Kleist, Hirshfeld, John Sloan, Steig, William Gropper, and others in the early 1930s, these satirical statements established for Guston a preexisting, legitimized agency into which his feelings of outrage and contempt could be poured. If anything, by 1971, the year that *Poor Richard* was made, the caricature, especially the political caricature, had long been superseded by the comic strip and book, and to a leaser extent, the individual cartoon as a visual category. The genre, for the most part, had devolved into a rarified species of imagery, showing up primarily in specialized literary publications such as the *New York Review of Books* (where David Levine's elaborations of Nixon, with a magnified, bulbous and shaded nose, appeared frequently during this period[100]).

In fact, by the mid-1940s, near the end of the World War II, when Saul Steinberg's tiny cartoons of Hitler and Mussolini appeared in the *New Yorker*, and the salacious spoofs of various senators by Theodor Seuss Geisel (Dr.

Seuss) were printed in PM, the caricaturing of political leaders by visual artists had almost become, at least in America,[101] an underground genre. With *Americana* long since defunct and its East Coast rival, the *New Masses*—in which artists such as George Bellows, William Glackens, and later Gropper always found an outlet for their cartoons—on its way out, few forums continued to exist for political caricature, let alone for dissent.

While copious renderings of Nixon were produced throughout his presidency (and beyond Watergate), these remained the primary territory of journalists, such as Jules Feiffer, who was among Nixon's most ardent slayers. His comic strip in the *Village Voice*, through its extended layout and serial narrative, expounded with great wit from 1967 to 1973 on Nixon's various acts of hypocrisy. Of course, singularized depictions of Nixon were printed in the daily newspapers, such as the *Washington Post* and the *Los Angeles Times*, where cartoonists such as Herblock and Paul Conrad continued to hammer and rail against the president throughout Vietnam, his trip to China and Watergate, being among his most sardonic, hard-hitting, and comic detractors. Guston surely knew many of these images, syndicated as they were in papers with high circulations. But the risk that he brought to *Poor Richard*, with its uncompromising phallic interpretation and scatological references, like those caricatures in *Americana* and in much earlier precedents such as Philipon's *Charivari*, could never have been pulled off in a mass media publication, what with the editorial constraints posed by the interests of its advertisers and desire for a broad readership. With its provocative, purposefully antagonistic content, *Poor Richard* is a radical work, which even within the context of the art world in the late twentieth century was anomalous, finding little comparison and niche.

While some artists, such as Leon Golub, Öyvind Fahlström, and Peter Saul, with clearly no awareness of Guston's *Poor Richard*, mined the visages of contemporary dictators and oppressive leaders for signs of their innate monstrosity through their paintings,[102] these types of examples remained isolated and occasional. Moreover, they were offset by the unabashedly decorative and upbeat portraits of Mao by Andy Warhol (made after Nixon's trip to China and neutralized by celebrity), which are distinctly uncritical and accepting of, if not enthralled by, the aura and mechanisms of power.

Within the arena of the comic book, R. Crumb, a cartoonist and the creator of *Zap* comics and *Fritz the Cat*, took on former vice president Nixon in his sketchbooks in the early 1960s, bestowing Nixon "The Clod Award of the Month."[103] However, this type of acerbic jab was not pursued by Crumb in any systematic or comprehensive manner, at least when it came to Nixon and other leaders. By contrast, *MAD* magazine, for example, did make a more sustained effort to weave the president and wife Pat into its wacky, offbeat political coverage.[104] Guston, though, was unaware of Crumb's work until around 1970—and most likely was not a monthly reader of *MAD*, however broad his reading and interest in the American comic strip—when Clark Coolidge, a poet whose conversation and friendship he deeply valued, compared the piles of imagery in his late work to the cartoons and comic strips of this underground hero.[105] Crumb acknowledged a certain visual debt to Guston in his *Zap* comics in the late 1970s, elaborating on Guston's enlarged shoes and Cyclopean heads (which replaced the Klan as a self-portrait in his work around 1973), but this tribute remained one-sided. Guston was simply out of the loop when it came to the contemporary comic book, finding more meaningful examples in his childhood.

A FABLE ON THE CORRUPTED STATE OF POLITICS AND THE DEMISE OF MODERNIST ART

Actually, *Poor Richard* is an homage to Benjamin Franklin, America's first cartoonist, and the creator of an almanac or book of humorous aphorisms from which Guston took the title of his satire on Nixon.[106] In a reverse spin on this erstwhile namesake, Guston inverts Franklin's book of prudence, with its pithy sayings and sobering truths, into a visual folly or double-entendre on the fate of an American president. *Poor Richard*, in Guston's interpretation, was too taken by his own self-serving homilies (remember the Checkers speech) to abide by any conventional wisdom. As a fable on both the corrupted state of politics and the demise of modernist art, Guston's *Poor Richard* emerges as an endpoint, a work which demarcates the loss of idealism within a culture and within an aesthetic movement. Unlike Franklin's cartoons and amusing bits of knowl-

edge or dictums, which were intended to be morally instructive, Guston's version of *Poor Richard* is disabused of the idea of progress, registering instead a prevailing sense of distrust in government and an incipient hopelessness.

As such, it is a remarkable cultural artifact, in addition to being superb political satire, hinged at a historic moment when the Democratic Left was becoming weary of expressing moral outrage, knowing its earlier attempts at mobilizing protesters against racial inequity and the war in Vietnam had been curtailed in 1968 by the assassinations of two political optimists: Martin Luther King, Jr., and Robert Kennedy. With the election of Richard Nixon, and the end of Lyndon Johnson's Great Society, a program which started the war on poverty, liberal politics shifted its focus, from larger social and economic agendas to special-interest groups representing various minorities. With cultural politics about to take over the academy,[107] emphasizing "difference" and "identity" over notions of unity, the Left became fractured, made up of competing interests upon which Nixon and subsequent Republicans such as Ronald Reagan, George Bush, and Newt Gingrich never ceased to capitalize. And within the context of the increasingly contentious and divided political Left, and constant bullying from the Right, Guston probably felt that the release of *Poor Richard* would be read only for its sensation, its wit and satire lost in the crossfire.

"LET US BE *AS TENACIOUS AS HE IS*—LET'S NOT LEAVE HIM ALONE"

While *Poor Richard* remained hidden in Guston's studio throughout the rest of his life, his ambivalence always displacing whatever momentary inclination he felt about publishing the work, he continued, even after Watergate, to trail Nixon. In a letter to Bill Corbett in 1975, he wrote that "I look, I *look*, Nixon watcher that I am, for the scraps of news—(now near the weather & shipping pages) of our own—as you say, our very own martyr. Well, let us be as tenacious as he is—let's not leave him alone."[108] During his monthly trips to teach at Boston University from 1973 to 1978, Guston enjoyed meeting Corbett for dinner and pounding, like Roth, on the soon to be former president.

Their mockery also became fodder for their art, occasioning Corbett's poem "The Richard Nixon Story," written after Nixon was ousted from the White House, and which Guston subsequently incorporated into a drawing—one of his poem-pictures[109]—where Nixon is represented with a huge, splayed foot afflicted with phlebitis. "The man who would never leave well enough alone," as Corbett writes, is doomed, despite "his wildest dreams," to a certain fate.

"I loved the Richard Nixon Story—the *tone*, just right—a certain mixture of the pathetic, sour disgust, all at once,"[110] Guston wrote to Corbett after reading his work. Both the artist and poet caught Nixon, as Corbett wrote in his poem, "sad, alone and aggressive in splendid misery." Unlike the assurance with which he operates throughout the first half of *Poor Richard*, before his trip to China, Nixon, here in the drawing with a tear in his eye, comes across as wallowing in gargantuan self-pity, but still clearly a dick-head with his engendered nose. Guston thought "The Richard Nixon Story" was a perfect match to *Poor Richard*. As he said, it possessed the same "sort of pithy burlesque—not just satire or cartoon (which is easy) but a sort of mock sympathy which thinly disguises a deep, *deeper* disgust."[111] It also represented a quizzical antidote to his earlier and fuller treatment of the president in which he forecasts he will go down in history as a "Nixon Cookie." Although defeated and diseased in the drawing to the poem and seemingly no longer capable of malice, Guston now questioned, Would he be vindicated after Watergate? Recent attempts at his rehabilitation leave us wondering.[112]

Roth, whose contempt for Nixon has never abated (Nixon's funeral is woven into his recent novel *I Married a Communist*), noted a few years after the publication of *Our Gang*, "The wonder of Nixon (and contemporary America) is that a man so transparently fraudulent, if not on the edge of mental disorder, could ever have won the confidence and approval of a people who generally require at least a little something of the 'human touch' in their leaders."[113] In *Poor Richard*, as in *Our Gang*, Nixon is, of course, devoid of humanity, a bizarre, preposterous figure whose pronounced characteristic is his dishonesty. That Guston and Roth elaborated on these traits before Watergate argues for the ongoing possibility and strength of political satire.

NOTES

1. Four of these images were illustrated in Dore Ashton, *Yes, but ...: A Critical Study of Philip Guston* (New York: Viking Press, 1976), 158. Subsequently, one drawing was reproduced by Robert Storr in *Philip Guston* (New York: Abbeville Press, 1986), 53. Kosme Maria de Baranao included an illustration of one of the works in *Philip Guston: La raiz del dibujo = The Roots of Drawing*, exhibition catalog, Spanish and English (Bilbao: Sala Rekalde, 1993), 252; and William Corbett devoted a chapter to the discussion of these caricatures in *Philip Guston's Late Work: A Memoir* (Cambridge, Mass.: Zoland Books, 1994), 50ff.

2. Philip Roth, "Breast Baring," *Vanity Fair* (October 1989): 94.

3. Philip Guston, "Philip Guston Talking," in *Philip Guston: Paintings 1969–1980*, exhibition catalog (London: Whitechapel Art Gallery, 1982), 53.

4. On Guston's associations with writers during the last decade of his life, see Debra Bricker Balken, *Philip Guston's Poem-Pictures*, exhibition catalog (Andover, Mass.: Addison Gallery of American Art, 1994).

5. Roth, "Breast Baring," 99.

6. Musa Mayer, *Night Studio: A Memoir of Philip Guston* (New York: Knopf, 1988), 168. Guston produced a drawing or caricature of himself and Roth, which he titled *Mutt and Jeff*, and which he gave to Roth after the publication of his *Great American Novel* in 1972.

7. Philip Roth, interview with the author, New York, N.Y., April 23, 1998.

8. Ibid.

9. Roth, "Breast Baring," 99.

10. Philip Roth, *Our Gang (Starring Tricky and His Friends)* (New York: Random House, 1971), 6.

11. Ibid.

12. Philip Roth, "On Our Gang," in *Reading Myself and Others* (New York: Farrar, Straus and Giroux, 1975), 45

13. Roth, *Our Gang*, 29–30.

14. Roth, "On Our Gang," 47.

15. Roth, interview with the author.

16. Roth, "On Our Gang," 49.

17. Ibid., 53.

18. On Roth's decision to develop his essay, "Imaginary Conversation with Our Leader," which appeared in the *New York Review of Books* on May 6, 1971, followed by "Imaginary Press Conference with Our Leader" on June 3, 1971, into *Our Gang*, see Walter Clemons, "Joking in the Square," in *Conversations with Philip Roth*, ed. George J. Searles (Jackson: University of Mississippi Press, 1992).

19. Roth "On Our Gang," 51.

20. Roth, interview with the author.

21. A few of the drawings are dated August 1971, which suggests the entire series was made at once.

22. Roth, "Breast Baring," 99.

23. Roth, interview with the author.

24. Guston made more than eighty drawings for *Poor Richard* but edited a number from the binder in which he assembled the images, a process which reveals his assiduousness in determining their sequence as well as the way in which they would be received by the viewer. In preparing this project for publication thirty years later, I have abided by his original narrative order.

25. Richard Nixon, *RN: The Memoirs of Richard Nixon* (1978; New York: Simon and Schuster, 1990), 3. Garry Wills, in *Nixon Agonistes, The Crisis of the Self-Made Man* (Boston: Houghton Mifflin, 1970), 24, notes Nixon's use of this metaphor throughout his career, as does Jules Witcover, *The Year the Dream Died: Revisiting 1968 in America* (New York: Warner Books, 1997), 307.

26. Nixon, *RN: The Memoirs of Richard Nixon*, 20.

27. Nixon referred to the "Checkers speech" in the context of a professional crisis in his book *Six Crises* (Garden City, N.Y.: Doubleday, 1962), 115, in which he again defended his honor against illegal use of campaign funds during his run for the vice presidency.

28. Nixon, *RN: The Memoirs of Richard Nixon*, 103.

29. Ibid., 335.

30. On Kissinger's July 1971 trip to China to lay the groundwork for Nixon's later visit to meet Mao Zedong and Zhou Enlai in February 1972, see Patrick Tyler, *A Great Wall: Six Presidents and China, An Investigative History* (New York: Public Affairs, 1999), 93 ff., and James Mann, *About Face: A History of America's Curious Relationship with China, from Nixon to Clinton* (New York: Alfred A. Knopf, 1999), 26ff.

31. Nixon in Tyler, *A Great Wall*, 108.

32. Nixon, *RN: The Memoirs of Richard Nixon*, 549.

33. Ibid.

34. Roth, interview with the author.

35. Ibid.

36. *Newsweek* (June 24, 1974): 15.

37. Harold Rosenberg, "Thugs Adrift," reprinted in Harold Rosenberg, *The Case of the Baffled Radical* (Chicago: University of Chicago Press, 1985), 68–75.

38. Philip Guston to Harold Rosenberg, January 11, 1974, Harold Rosenberg Papers, J. Paul Getty Library, Santa Monica, California.

39. William Corbett, interview with the author, Boston, November 11, 1999.

40. See Norman Mailer, *Miami and the Siege of Chicago* (New York: Primus, 1968); Gore

Vidal, *An Evening with Richard Nixon* (New York: Random House, 1972); and Emile de Antonio, *Millhouse: A White Comedy*, film, 1971.

41. William Corbett to Debra Balken, November 11, 1999, private papers.

42. Philip Guston to Dore Ashton, spring 1971, Dore Ashton Papers, Archives of American Art, Smithsonian Institution, Washington, D.C.

43. Philip Roth in Mayer, *Night Studio*, 177.

44. Clement Greenberg was the chief architect of formalist theory in the United States. Guston's work did get support from writers such as Harold Rosenberg and Thomas Hess, whose aesthetic views were less codified and more expansive than Greenberg's.

45. Philip Guston to Philip Roth, 1973, Philip Roth Correspondence, Manuscript Division, Library of Congress.

46. Philip Guston to Philip Roth, 1978, Roth Correspondence.

47. Irving Howe, "Philip Roth Reconsidered," *Commentary* 54, no. 6 (December 1972): 69–77.

48. Philip Guston to Philip Roth, November 27, 1974, Roth Correspondence.

49. Philip Guston to Philip Roth, February 20, 1974, Roth Correspondence.

50. Philip Guston in Harold Rosenberg, "On Cave Art, Church Art, Ethnic Art, and Art," reprinted in Rosenberg, *The Case of the Baffled Radical*, 209.

51. Philip Guston in Mark Stevens, "A Talk with Philip Guston," *New Republic* (March 15, 1980): 27.

52. Ibid.

53. Philip Guston in Harold Rosenberg, "Recent Paintings by Philip Guston," reprinted in Rosenberg, *The Case of the Baffled Radical*, 197.

54. Guston, "Philip Guston Talking," 53.

55. Philip Guston to Dore Ashton, "List of people important to me," Ashton Papers.

56. Philip Guston to Philip Roth, 1973, Roth Correspondence.

57. Philip Guston in William Berkson, "Dialogue with Philip Guston 11/1/64," *Art and Literature*, no. 7 (winter 1965): 67–68.

58. Philip Guston to Dore Ashton, March 14, 1969, Ashton Papers.

59. Philip Guston, "Random Notes," September 1970, Ashton Papers.

60. Philip Guston in Jerry Talmer, "'Creation' Is for Beauty Parlors," *The New York Post* (April 9, 1977): 22.

61. Ibid.

62. Philip Guston to Bill Berkson, September 15, 1970, Bill Berkson Papers, University of Connecticut Library, Storrs, Connecticut.

63. Ibid.

64. Guston, "Philip Guston Talking," 52.

65. For illustrations and a discussion of these images, see Ashton, *Yes, but …*, 8ff.

66. Guston, "Random Notes."

67. Guston in Talmer, "'Creation' Is for Beauty Parlors."

68. Guston in Rosenberg, "Recent Paintings by Philip Guston."

69. Philip Guston, "Philip Guston: A Day's Work," *Art Now: New York* 2, no. 8 (1970): n.p.

70. First noted by Corbett in *Philip Guston's Late Work: A Memoir*, 50.

71. Philip Guston, interview with Klaus Kertess, April 24, 1966, Archives of American Art, Smithsonian Institution.

72. Philip Guston in John Baur, *Nature in Abstraction*, exhibition catalog (New York: Whitney Museum of American Art, 1958), 40.

73. Philip Guston to Bill Berkson, October 7, 1973, Berkson Papers.

74. Ibid.

75. Philip Guston in Harold Rosenberg, "Conversations: Guston's Recent Paintings," *Boston University Herald* 22, no. 3 (fall 1974): 56.

76. For a description of these events, specifically of Guston's memory of the Klan and of his reading of their injustices inflicted on African Americans, especially the Scottsboro case in 1932, see Ashton, *Yes, but …*, 27, Storr, *Philip Guston*, 53ff., and Mayer, *Night Studio*, 8ff. Moreover, at the time of the Scottsboro case, Guston worked on a mural with Reuben Kadish and Harold Lehman on the social history of the African American for the John Reed Club, only to have it destroyed by "a band of raiders," according to Ashton. This injustice was compounded during a lawsuit brought by the artists against these "raiders," which they lost.

77. Philip Guston to Bill Berkson, January 26, 1972, Berkson Papers.

78. While Guston's late work was sympathetically reviewed by some critics, including Berkson, Ashton and Rosenberg, and by a younger generation of writers such as Kenneth Baker ("Philip Guston at Boston University," *Art in America* 62, no. 3 [May–June 1974]: 115) and Roberta Smith ("The New Gustons," *Art in America* 66 [January–February 1978]: 100–105), some critics as late as 1980, the year of Guston's death, still found his painting an anathema. See Peter Schjeldahl, "Self-Abuse on Parade," *The Village Voice* (July 15–21, 1981): 72.

79. Guston in Rosenberg, "Recent Paintings by Philip Guston," 185.

80. Philip Guston in *Philip Guston: A Life Lived, 1913–1980*, a film by Michael Blackwood Productions, Inc., New York, 1980.

81. Philip Guston to Bill Berkson, Saturday, undated, Berkson Papers.

82. Guston in Mayer, *Night Studio*, 152.

83. Ibid., 13.

84. For an analysis of the parallels between Herriman's work and surrealism, see Adam Gopnik, "The Genius of George Herriman," *The New York Review of Books* (December 18, 1986): 19–28.

85. On the way in which Guston drew on the images from these various cartoon and comic strips, see Storr, *Philip Guston*, 52, and Adam Gopnik, "Caricature," in *High &*

Low, Modern Art and Popular Culture, exhibition catalog (New York: Museum of Modern Art, 1990), 223–226.

86. *Americana* (May 1933): n.p.

87. *Americana* (April 1933): n.p.

88. A number of historic distinctions separate the emergence and engagement of the genres of the caricature, cartoon, and comic strip. For explanations of these histories, I direct the reader to, among the vast literature on these subjects, Gopnik, "Caricature," as well as to earlier studies such as E. H. Gombrich, *Art and Illusion: A Study in the Psychology of Pictorial Representation* (New York: Pantheon Books, 1959), 336ff., and Edward Lucie-Smith, *The Art of Caricature* (Ithaca, N.Y.: Cornell University Press, 1981). In addition, I found "The Issue of Caricature," *Art Journal*, ed. Judith Wechsler, vol. 43 (winter 1983), and David Kunzle, *The History of the Comic Strip* (Berkeley, Calif.: University of California Press, 1990), to be helpful accountings. In discussing Guston's caricatures of Richard Nixon, I abide by the historic description of the caricature and the cartoon as being deeply satiric, and the comic strip, except when aimed at politics, to be primarily entertaining or funny. These categories do, however, as most authors observe, both collapse and frequently overlap in the early twentieth century, and I doubt that Guston was overly preoccupied with their once rigid distinctions.

89. For illustrations of some of these caricatures, see Ashton, *Yes, but …*, where they are scattered throughout the text, and de Baranao, *Philip Guston*, 191ff.

90. Harold Rosenberg, "Liberation from Detachment," reprinted in *The De-definition of Art* (Chicago: University of Chicago Press, 1972), 132.

91. Until the exhibition of Guston's drawings organized by de Baranao (see note 1, above), none of these caricatures had been integrated into retrospective assessments of his work.

92. Guston in Jan Butterfield, "A Very Anxious Fix," *Images and Issues* 1, no. 1 (summer 1990), 31.

93. Noted by Ashton, *Yes, but …*, 96.

94. Fletcher Martin, "Retrospective thoughts on my friendship with Philip," Ashton Papers; and Philip Guston to Bill Berkson, April 4, 1974, Berkson Papers.

95. Ashton, *Yes, but …*, 95

96. Reproduced in Storr, *Philip Guston*, 37.

97. Noted in Ashton, *Yes, but …*, 80.

98. For a reproduction of this image, see de Baranao, *Philip Guston*, 28. For a discussion of the circumstances which surrounded the canceling of the poetry series at the Smithsonian Institution, see Stanley Kunitz, "Remembering Guston," in Balken, *Philip Guston's Poem-Pictures*, 65.

99. Lucie-Smith, *The Art of Caricature*, 13; and see note 88, above.

100. Corbett (interview with the author), remembers that Guston found Levine's caricatures of Nixon "mild and journalistic."

101. Lucie-Smith attempts to make a case for American caricatures lacking "risk" in the twentieth century (*The Art of Caricature*, 100). From my perspective, the examples of caricatures in *Americana* and the *New Masses* would seem to counter this claim. Although I do agree that after World War II, only a few, isolated examples exist of artists working within this territory in the United States. These types of forums for dissent, for the most part, ceased to exist after 1945.

102. On Golub's portraits of political leaders such as Franco, Nelson Rockefeller, Augusto Pinochet, and Zhou Enlai, among others, see Lynn Gumpert and Ned Rifkin, *Golub*, exhibition catalog (New York: Museum of Contemporary Art, 1984); on Saul's pictures of Ronald Reagan, see *Peter Saul, Political Paintings*, exhibition catalog (New York: Frumkin/Adams Gallery, 1990); and on Fahlström's images of Nixon and Kissinger, many of which were integrated into a comic-strip-like format—Fahlström like Guston was deeply attracted to the work of Herriman—see *Öyvind Fahlström*, exhibition catalog (Valencia: IVAM Centre Julio González, 1992).

103. R. Crumb, *The Complete Crumb*, vol. 1, *The Early Years of Bitter Struggle*, ed. Gary Groth with Robert Fiore (Seattle: Fantagraphics Books, 1991), 13.

104. I am grateful to Tom Nozkowski for bringing *MAD* magazine and its images and sustained coverage of Nixon to my attention.

105. Clark Coolidge compared Guston's late work to R. Crumb's, in Bill Berkson, "The New Gustons," *Artnews* 69, no. 6 (October 1970): 44.

106. Shortly after Nixon was elected president, a number of spoofs on Franklin's *Poor Richard's Almanack* appeared; they drew on Nixon's speeches rather than Franklin's wisdom for their aphorisms. See *The Almanack of Poor Richard Nixon*, ed. Jack Shepherd and Christopher Wren (Cleveland: World Publishing Company, 1968), and *Quotations From the Would-Be Chairman: Poor Richard's Very Own Words*, ed. M. B. Schnapper (Washington, D.C., Public Affairs Press, 1968). Whether Guston knew of these spoofs is not revealed in any of the correspondence or writing that I consulted.

107. On the subject of the rise of cultural politics within the academy, see, among many diverse interpretations, Richard Rorty, *Achieving Our Country: Leftist Thought in Twentieth-Century America* (Cambridge, Mass.: Harvard University Press, 1998).

108. Philip Guston to William Corbett, April 8, 1975, private papers.

109. "The Richard Nixon Story" is illustrated in Balken, *Philip Guston's Poem-Pictures*, 61.

110. Philip Guston to William Corbett, September 17, 1974, private papers.

111. Philip Guston to William Corbett, April 8, 1975, private papers.

112. Among the most recent efforts to rehabilitate Nixon as a political character, see Monica Crowley, *Nixon in Winter* (New York: Random House, 1998), and, also by Crowley, *Nixon Off the Record: His Candid Commentary on People and Politics* (New York: Random House, 1996).

113. Philip Roth in Walter Mauro, "Writing and the Powers-That-Be," reprinted in Searles, *Conversations with Philip Roth*, 88.

ACKNOWLEDGMENTS

Philip Guston's "Poor Richard" comes on the heels of an exhibition which I curated in 1994 for the Addison Gallery of American Art which examined Guston's interactions with writers during the last decade of his life. Known as *Philip Guston's Poem-Pictures*, this project highlighted the remarkable and numerous drawings which grew out of Guston's collaborations with poets such as Clark Coolidge, Bill Berkson, Stanley Kunitz, William Corbett, and his wife, Musa McKim, from approximately 1970 to 1976. While working on this overlooked aspect of Guston's late work, I stumbled upon the equally remarkable and certainly more provocative *Poor Richard*, the seventy-five-odd drawings which make up this book. These images too emanated from a meaningful friendship with a writer, that is, from Guston's social and intellectual exchanges with Philip Roth, who shared with Guston, among many interests, a deep contempt for then president Richard Nixon.

I am deeply indebted to Musa Mayer, Guston's daughter, and David McKee, of the McKee Gallery, New York, for the opportunity to work on *Philip Guston's "Poor Richard."* To say that it has been fun is not to diminish the ultimately serious and condemning content of this satire, but I have derived a great deal of pleasure from this project.

I am also very appreciative of the interest which Philip Roth took in this book. While he attempted to persuade Guston on numerous occasions to publish this set of drawings in the early 1970s, all of which induced the artist's great ambivalence, he sustained this commitment some thirty years later by responding to my ongoing requests for information with promptness, and he enthusiastically made himself available to be interviewed. That he also made his papers, deposited at the Library of Congress and containing crucial correspondence from Guston, available to me, I am also extremely grateful.

Similarly, William Corbett, a poet whom Guston befriended while teaching in Boston during the mid-seventies, also turned over his letters for my perusal, while generously availing himself for numerous conversations and inquiries. I have enjoyed both his take on and impersonation of Nixon as well as his countless yarns of Guston's reactions to the by then ousted president. Corbett also attempted to find a publisher for *Poor Richard*, knowing it to be an extraordinary satire, but like Roth encountered the same resistance from Guston.

The research for my accompanying essay was conducted primarily at three sites: the Manuscript Division of the Library of Congress; the New York branch of the Archives of American Art, Smithsonian Institution (the extraordinary resources of which I rely upon for almost all of my curatorial and writing projects); and the University of Connecticut Library, Storrs, Connecticut. I extend my thanks to the staffs of all three of these institutions but, in particular, acknowledge Alice Birney Lotvin of the Library of Congress, who made a special effort to make the voluminous Philip Roth correspondence accessible to me on two separate trips to Washington, D.C.

Numerous other colleagues, friends, and relatives were of help in shaping the conceptual framework for my essay. To name just a few, I am thankful (again) to David McKee for sharing his memories of Guston's loathing of Nixon, and of his abiding interest in Mickey Mouse; Bill Berkson, who has always been magnanimous with his recollections and archival sources; Tom Nozkowski, an artist who scoured through past issues of *MAD* magazine (where he works part-time) to find how that publication treated Nixon; Deborah Rothschild and Allen Weiss, who enthusiastically supported this project in ineffable ways from the beginning; and to my brother, Scott Kerr Bricker, Jr., who has had a long-standing and infectious interest in the genres of the comic strip, caricature, and cartoon.

It has been a great pleasure to work with the University of Chicago Press on this book. For its stunning design, I am indebted to Mike Brehm; for the sensitive copy editing I owe a debt to Russell Harper.

But above all, I am grateful to Michael Denneny for the introduction to Douglas Mitchell, who steered me to Susan Bielstein, my editor. Besides her deft and thoughtful editorial insights, her abundant cheer, along with that of her assistants, Anthony Burton and Paige Kennedy-Piehl, has made this book a joy on which to work.

All drawings are in china ink on paper and measure 10½" × 14⅞" (26.7 × 37.8 cm). Collection of Musa and Tom Mayer.

DEBRA BRICKER BALKEN is an independent curator and writer who has assembled
numerous exhibitions in the United States, including the retrospective of Arthur Dove's work which appeared at the
Whitney Museum of American Art. She is the author of several books and catalogues, including
Arthur Dove: A Retrospective and *Alfredo Jaar: Lament of the Images.*

The images in this book appear courtesy of the estate of Philip Guston.

Photography by Michael Karol, Fine Art Services, New York.

The University of Chicago Press, Chicago 60637
The University of Chicago Press, Ltd., London
© 2001 by The University of Chicago
All rights reserved. Published 2001
Printed in Hong Kong
10 09 08 07 06 05 04 03 02 01 1 2 3 4 5
ISBN: 0-226-03621-9 (cloth)
ISBN: 0-226-03622-7 (paper)

Library of Congress Cataloging-in-Publication Data
Balken, Debra Bricker.
Philip Guston's Poor Richard / Debra Bricker Balken.
p. cm.
Includes bibliographical references. ISBN 0-226-03621-9 (acid-free paper) ISBN 0-226-03622-7 (pbk.: acid-free paper)
1. Nixon, Richard M. (Richard Milhous), 1913– —Caricatures and cartoons. 2. American wit and humor, Pictorial. I. Title: Poor Richard. II. Guston, Philip, 1913– III. Title.
E856.B34 2001
973.924′092—dc21 2001000741

This book was printed on acid-free paper.